MANGA PRO SUPERSTAR WORKSHOP

WORKSHOP

How to Create and Sell Comics and Graphic Novels

Colleen Doran

IMPACT
CINCINNATI, OHIO
www.impact-books.com

ABOUT THE AUTHOR

Colleen Doran began her comics career at age five after winning a contest sponsored by the Walt Disney Company. She landed her first professional commercial work at age fifteen.

With more than five hundred credits to her name as an artist, writer and designer, Colleen is considered to be the first solo female creator of a graphic novel series in the U.S. Published by Image Comics, A DISTANT SOIL has four volumes in print. She's also worked on projects such as THE AMAZING SPIDERMAN, WONDER WOMAN, Neil Gaiman's THE SANDMAN, and THE BOOK OF LOST SOULS by Babylon 5 creator J. Michael Straczynski.

Colleen has been interested in manga since the 1980s. She worked as a consultant for Japanese toy manufacturer Bandai, and participated in the U.S./Japan Manga Seminar sponsored by Tezuka Productions in Tokyo. She lectured on manga at the American Library Association (ALA) and the Smithsonian Institution, where she was artist in residence. Colleen's first book for IMPACT, GIRL TO GRRRL MANGA, is currently available.

Manga Pro Superstar Workshop. Copyright © 2008 by Colleen Doran. Manufactured in China. All rights reserved. No part of this book may be reproduced in any form or by any electronic or mechanical means including information storage and retrieval systems without permission in writing from the publisher, except by a reviewer who may quote brief passages in a review. Published by IMPACT Books, an imprint of F+W Publications, Inc., 4700 East Galbraith Road, Cincinnati, Ohio, 45236. (800) 289-0963. First Edition.

Other IMPACT Books are available from your local bookstore, art supply store or direct from the publisher at www.fwbookstore.com.

12 11 10 09 08 5 4 3 2 1

DISTRIBUTED IN CANADA BY FRASER DIRECT
100 Armstrong Avenue
Georgetown, ON, Canada L7G 5S4
Tel: (905) 877-4411

DISTRIBUTED IN THE U.K. AND EUROPE BY DAVID & CHARLES
Brunel House, Newton Abbot, Devon, TQ12 4PU, England
Tel: (+44) 1626 323200, Fax: (+44) 1626 323319
Email: postmaster@davidandcharles.co.uk

DISTRIBUTED IN AUSTRALIA BY CAPRICORN LINK
P.O. Box 704, S. Windsor NSW, 2756 Australia
Tel: (02) 4577-3555

Library of Congress Cataloging in Publication Data
Doran, Colleen
 Manga pro superstar workshop : how to create and sell comics and graphic novels / Colleen Doran. -- 1st ed.
 p. cm.
 Includes bibliographical references and index.
 ISBN-13: 978-1-58180-985-5 (pbk. : alk. paper)
 ISBN-10: 1-58180-985-9 (pbk. : alk. paper)
 1. Comic books, strips, etc.--Japan--Technique. 2. Comic books, strips, etc.--Authorship. 3. Comic books, strips, etc.--Marketing. 4. Cartooning--Technique. 5. Graphic novels--Authorship. 6. Graphic novels--Marketing. I. Title.
 NC1764.5.J3D67 2007
 741.5'1--dc22 2007019294

Edited by Kelly Messerly and Mona Michael
Designed by Wendy Dunning
Production coordinated by Matt Wagner

METRIC CONVERSION CHART

To convert	to	multiply by
Inches	Centimeters	2.54
Centimeters	Inches	0.4
Feet	Centimeters	30.5
Centimeters	Feet	0.03
Yards	Meters	0.9
Meters	Yards	1.1

DEDICATION

For Takeyuki Matsutani and everyone at Tezuka Productions.

To Fred Schodt and to my idol, Riyoko Ikeda.

And to Leslie Sternbergh for introducing me to Japanese comics.

ACKNOWLEDGMENTS

As always, to my extremely supportive family, my eternal thanks: my mother (my assistant) and my father (my rock).

Thanks again to my models Kacey Camp, Jarl Benzon, Craig Parker, Jed Brophy, Sandro Kopp and Shane Rangi.

Special thanks to Jeff Smith, J. Michael Straczynski, Junko Ito, Leslie France and Keith Giffen.

TABLE of CONTENTS

TOMAS HEREZ (20s - careless casual) puffs a cigarette amid a cluster of SMOKERS. He carries a shoulder slung portfolio - reacts to -

Maggie exits the building.

 TOMAS

How bad?

 maggie
On a scale of one to ten, ten being Hell? Fourteen.

 TOMAS
 (pitches cigarette)
At least they're consistent.

They fall into step side by side - proceed up the STREET.

 maggie
Ever occur to you that I could use a little moral support up there?

So you want to draw manga or comics?

I cannot tell a lie. This is probably the coolest job to be had. Now more than ever, people are reading manga and comics and getting into the comics business. There's never been a better time for it. There is so much variety and so many new publishers!

In fact, more people are reading graphic novels and manga these days than monthly comics. Graphic novels are winning major book awards, are available in libraries and schools across the country, and are being used as teaching tools in businesses. Thousands of new readers are enjoying and learning about sequential art.

EAST MEETS WEST

There's also a lot of debate about which is better: manga- or Western-style comics. Both manga and Western comics have a lot to teach and to offer readers. As an artist, you can learn from both styles and use the tools and techniques of both. There's no reason to limit yourself to just one style, one genre, one type of anything. You can do whatever you want with your art.

I first became interested in manga in the 1980s, shortly after I got into the comics business. According to Scott McCloud, author of *Understanding Comics*, I was one of the first Western artists to use manga influences in my work. Yet, I've been working for Western companies like Marvel Comics, DC Comics, Image Comics, The Walt Disney Company and many others for years. Manga has helped me learn new ways of telling stories and has changed the way I draw pages. I now use Japanese tools (e.g., tone sheets and pens) to draw superhero comics. But I still use Western paper, and I like most of the Western storytelling techniques. You, too, can pick and choose from an international menu of sources as you decide what you want to draw, how you want to draw it, what you want to say and how you want to say it.

This book will show you some tools and techniques, some of which I've picked up from a variety of artists and writers, both in the U.S. and in Japan. You'll have a chance to try them out for yourself and then choose whatever you want for your own work. We'll also go over some of the things publishers expect and are looking for.

In the end, you have a lot of options for your comic story. If you're interested in print publishing, you'll find some tips here about what a publisher needs from you. If you have no interest in being a part of print publishing, that's fine, too! There are other ways to have your work seen and enjoyed around the world. If you have a website or if you can get in touch with many of the websites that post online comics, you can share your work without ever going to a publisher. You don't have to worry about making a lot of money at it: You can simply create comics and enjoy the thrill of having people read them—no matter who you are, how young you are or how much money you have.

If you can afford about twenty-five cents per page of work, you can create a graphic novel without expensive tools and software. Anyone can create a comic book!

I hope you enjoy the book, and if you want some more manga drawing tips, check out my other book, *Girl to Grrrl Manga: How to Draw the Hottest Shoujo Manga*, also published by IMPACT Books.

Thanks for reading, and good luck!

SOME WORDS TO KNOW

We'll be using a few terms specific to manga throughout the book: Mangaka is the Japanese word for cartoonist. Lots of people working in the manga style in the West prefer to be called mangaka. Of course, manga is the Japanese word for comics. OEL is the term for Original English Language manga—that is, a graphic novel created by a Western artist working in the manga style.

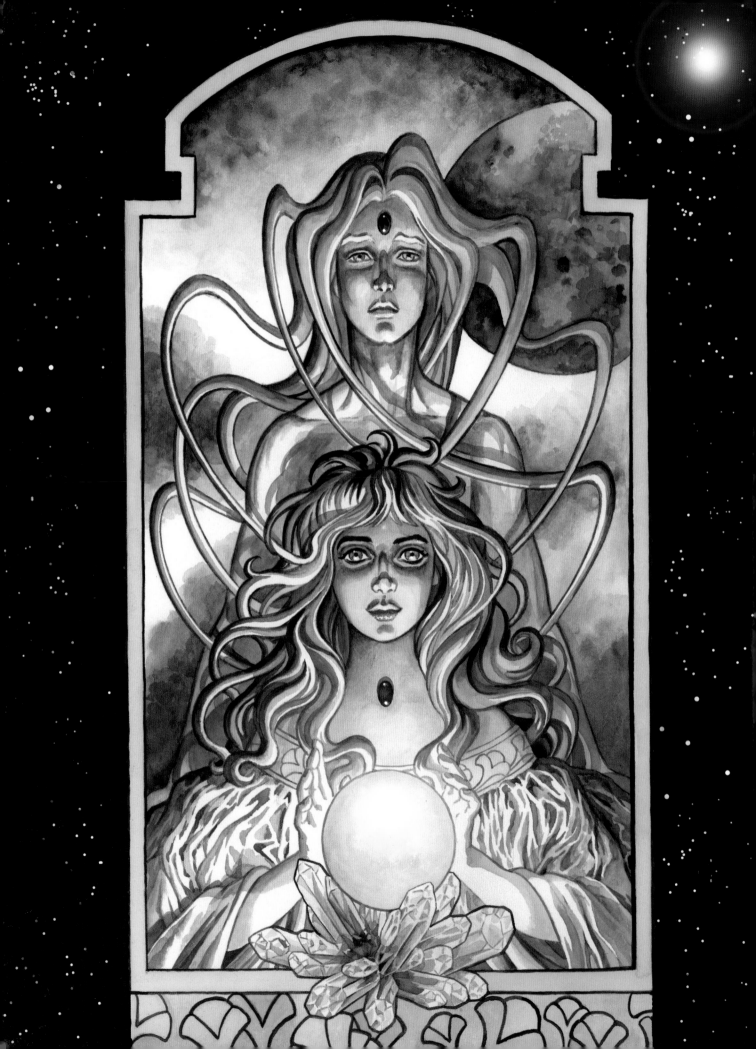

How to use this book

Simple tools and instruction

will get you, the aspiring creator, going on your dream projects quickly. There are some fantastic books out there for advanced manga and comics students, and I highly recommend some of them on page 124. They concentrate on storytelling theory and complex techniques, but few give step-by-step instructions for the beginner. When I was a young girl dreaming of my future comics career, I most enjoyed learning from books that not only explained but showed how things were created in simple steps. I've created this kind of book for you, one that focuses on tools and techniques and how to use them in different ways. Whether you aspire to create manga or Western-style comics, you'll learn multiple ways to create comic pages so you'll be able to make the best choices.

Some of the art may be simpler than you're used to seeing in published comics and manga. It is better to start simple. In fact, many of the techniques in this book are so easy that you'll learn the basics of tasks like lettering and applying tones in less than an hour! But getting good at these techniques takes time. Just because an exercise looks easy, don't be tempted to pass over it. The simplest techniques can be very important.

You'll find assignments scattered throughout. Try to complete a couple of them every week. Set deadlines for yourself and keep them. When you are a professional creator, you'll have to get used to meeting deadlines! Give yourself easy goals in the beginning and then increase the level of difficulty as you gain confidence.

After you've tried out the assignments, try them again, adapting them to your own needs and style ideas. Change the look of a character drawing and make changes in the page design. Experiment.

When you're ready to begin writing and drawing your own stories, start small. Remember, a graphic novel is a huge project. Even if you write and draw a new, finished page every day, five days a week, it will take you almost six months to complete an original graphic novel! So, start with a simple single page, then move on to a short story of eight pages. Then try a twenty-two-page story. When you have become comfortable with small assignments, move on to larger ones.

Creating a graphic novel requires commitment and planning. Work out your ideas with preliminary sketches and written outlines before beginning major work. It's exciting to just dive into your big book project and go, but every pro artist knows the value of building a strong foundation below a major structure. Pay close attention to the segments that will teach you how to plan your works.

Of course, the most important thing is to have fun. Whether you're an aspiring pro or an avid fan, may you never lose the joy of crafting your own stories. I sincerely hope this book helps you along.

Enjoy!

Western comics vs. manga

While you may think of manga as being all about big eyes and cartoony faces and Western comics as being all about superheroes beating up each other, you can draw manga and comics characters any way you like. The biggest difference between manga and comics is the storytelling style.

Generally, Western comics are like illustrated books and manga are like readable movies.

Western comics generally have at least six panels per page (often more) and sometimes have hundreds of words per page. Like a written novel, a Western graphic novel can take hours to read.

Manga often have no more than three or four panels per page, usually with only a few lines of dialogue. You may feel like you're not actually reading manga, but sharing an experience. An entire manga book can take a half hour to read or less.

Manga storytelling style may take a moment in time and spread it over many

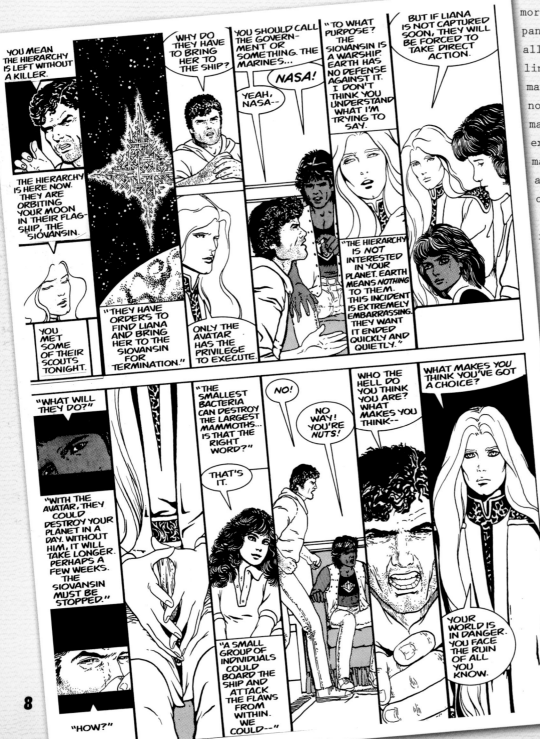

Western comics equal more text and panels
Here's a rather extreme example of a Western-style comic. Look at all those panels! At the time I drew this, I was heavily influenced by popular artist George Perez, who often drew comics pages with nine to fifteen panels per page. There is a lot of dialogue and a lot going on visually. The advantage to this type of comic is you get a lot of reading for your money!

pages. The effect is cinematic. A sense of suspended time is a key element of the manga style. The information on the page is absorbed by the reader at a glance. There is less story content per page, but a great deal of feeling.

Both types of storytelling are valid ways of expressing yourself as a cartoonist, and many cartoonists combine features of manga and Western comics.

The tight, heavy plotting and highly rendered, illustrated graphic novel storytelling style of Western comics is sometimes referred to as *compressed* storytelling. Manga storytelling style, on the other hand, is *decompressed* storytelling—the content of just a few panels of a Western comic might fill ten pages of a manga comic!

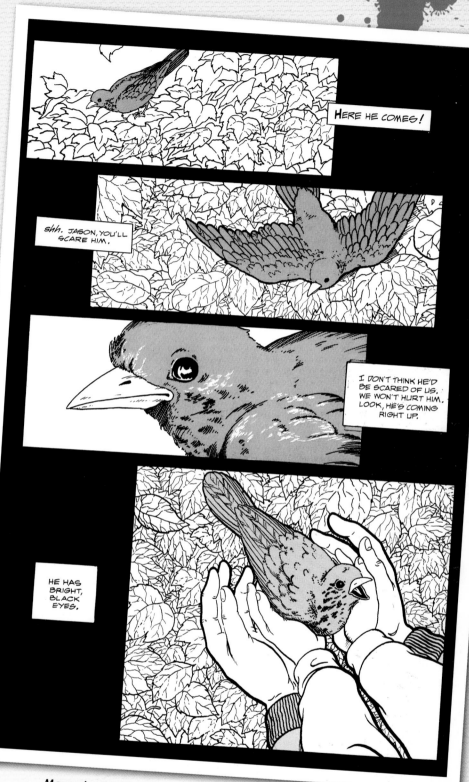

Manga-inspired page

This page is from the same comic as the previous page, though it uses manga storytelling techniques. Using just a few panels on the page, areas of negative space for contrast and limited use of dialogue are common features of manga.

How comics artists work

While there are many different ways to create comics, the three most common are what I call the studio system, the assembly line system and the complete cartoonist system.

THE STUDIO SYSTEM

The studio system is the most common way manga artists work. A *mangaka* (professional manga artist) is expected to draw and write at least one hundred pages per month. Often, the stories appear in very large comics collections with the work of a dozen or more other artists.

Mangaka can't meet these demands alone, so they usually have a studio of artists working with them. A major mangaka may only do the heads of characters while assistants complete the inking, tones, figures and backgrounds. Assistants don't receive official credit for their work, but you may have noticed little thank-you notes to them hidden among the panels of manga books. Each mangaka has an average of five assistants, though some employ up to twenty-five.

Sometimes assistants have specialties, so one might specialize in buildings and another in machines and vehicles. Others have to be adept at multiple tasks. A top master mangaka also enjoys the benefit of having a manager to handle finances and organize the studio and assignments.

Not every mangaka is so lucky. There are more than 4,000 professional mangaka in Japan, but of those, only the top 1,000 can really afford a full-time studio. The others must work with part-time assistants or rely on friends or family to pitch in. Others rotate assisting each other, rushing in to help out when someone gets behind schedule.

While top mangaka can become millionaires, it costs a lot to run a studio, pay salaries and rent expensive Tokyo workspace. They must be very dedicated and willing to sacrifice a great deal to become top cartoonists.

Editors play a major role in the work and lives of their artists. Editors are well educated from top universities and may actually suggest stories or even do a great deal of ghostwriting on the books they edit.

Every week, the artist and editor confer, usually on Sunday or Monday. The artist submits thumbnail drawings, which, after approval, become *shitagaki*, or pencil manuscripts, roughly penciled pages with word balloons and dialogue sketched in.

The editor may stay with the artist during this time to ensure that deadlines are met and that the work meets approval. Sometimes artists are asked to redo up to half of the layouts.

After a few days of intense labor for the mangaka, the team of assistants goes to work on other aspects of the story. The finished pages are completed by Friday and delivered to the publisher, where the final word balloons are added using a computer. It's an intense schedule, usually requiring artists to work at least six days—and often seven days—a week!

A few American cartoonists use a variation of the Japanese studio system, but most use the assembly line system.

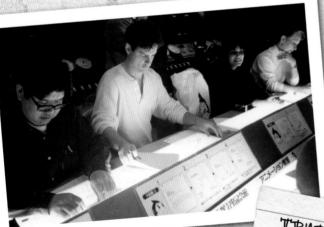

Practicing manga techniques
Jeff Smith, Vijaya Iyer and Anita Doran learn manga and anime production tips from Mangaka Masahiro at the Osamu Tezuka Manga Museum in Tokyo.

TRAPPED IN THE STUDIO!

The deadline demands on mangaka are brutal, and terror tales of mangaka being hounded by editors and locked up in studios until they meet their schedules are legendary. They are also true! Editors have a lot of control over the life and work of many manga artists.

THE ASSEMBLY LINE SYSTEM

In the U.S., comics are typically created at major comics companies via a kind of assembly line system, with artists and writers (often living in different states) communicating only by phone or email, and never seeing each other during the creative process. I have never met some of the people I work with, even though I have worked with them for years.

The process begins with the writer preparing a script (see pages 47-49). The writer then sends the script to the pencil artist, who draws his or her interpretations of the story, and then sends the art to an inker. The inker renders the pencil drawings into clean line art.

Art then goes to the colorist to be painted on computer. The word balloons are added, usually with a computer program. Depending on the publisher, the coloring and addition of word balloons may be completed in the office.

Comics from major companies like Marvel or DC are mainly created this way. There are always exceptions, though.

Original English Language (OEL) manga companies in the U.S. often use a variation of this system, even though they publish manga. Since few Western artists want to—or can afford to—work using the studio system, they divide tasks on some OEL manga among several creators. In these cases, it's common for all creators to receive credit in the book upon publication, though the master mangaka alone will get cover credit. An OEL manga may have a team that includes an artist who writes and pencils, another who inks, one who applies tones, and another who letters.

However, some creators prefer to do everything themselves, whether they work for a major publisher like Marvel or DC, or an OEL publisher like Tokyopop.

THE COMPLETE CARTOONIST

Many successful cartoonists are complete cartoonists, and even in Japan where assistants are commonly used, some mangaka prefer to work alone or with as few assistants as possible.

Hayao Miyazaki is the perfect example of the complete cartoonist, creating his famous work *Nausicää of the Valley of the Wind* using very

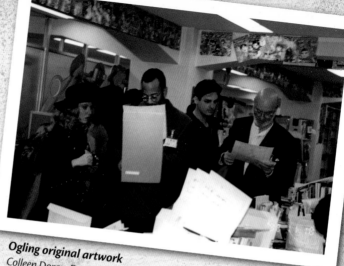

Ogling original artwork
Colleen Doran, Denys Cowan, Jeff Smith and Jules Ffeifer admire manga art originals and study manga production at the Shueisha publishing offices.

little help from other artists, and printing it entirely from his pencil drawings instead of inking them and using mechanical tones.

In the U.S., Jeff Smith is another outstanding example of the complete cartoonist. He wrote and drew his graphic novel series, *Bone* (which has generated sales of more than one million copies), single-handedly. He even did much of his lettering by hand.

The complete cartoonist has to master all the skills in comics. While I work with other artists and writers on my comics for major companies such as Marvel and DC, for my series, *A Distant Soil*, published by Image Comics, I write, draw, ink and letter the books by hand.

For the aspiring graphic novelist, your name on the cover of your creation—unhampered by various hands—is the ultimate goal. While great graphic novels can be created by teams of writers and artists, I don't know of any cartoonist who doesn't dream of being a complete cartoonist.

The advantages are obvious: You can own and control what you create yourself. The disadvantages are equally obvious: It takes a lot longer to do everything yourself, and sometimes the work can get pretty tedious. But if you want your work to be exactly as you envision it, becoming a complete cartoonist is the way to go. In this book, you'll get to try all the tasks that go into creating your own graphic novel using simple tools, so you can be a complete cartoonist, too!

TOOLS of the TRADE

If you already have a computer, you have a real advantage. There's a lot you can do to make your comics really shine with the right computer tools and experience.

However, you don't need expensive computers to start creating your own graphic novel. Any artist can create professional-quality work with inexpensive tools. Until fairly recently, almost all comics and manga were done by hand.

When I was growing up, my family was poor and could not afford expensive equipment and art schools. This did not stop me from achieving my goal of becoming a professional artist. I always give how-to advice that can be shared with anyone, especially with young artists who don't have big budgets. There's no reason you can't get started as a comics artist with an entire small studio of equipment that costs no more than one hundred dollars.

Let's Start with Paper

Choosing paper is a matter of preference, but no matter what you choose, always look for paper that is acid-free. Cheap paper has a chemical base that causes the paper to turn yellow and brittle over time. Have you noticed how an old newspaper crumbles away after about ten years? You don't want that to happen to your drawings! Acid-free paper resists aging and stays crisp and white.

DRAWING PAPER

Most drawing paper comes in three finishes: smooth, fine and vellum. Smooth surfaces can be almost as slick as glass, fine surfaces have a slight texture, and vellum can be rough. Different brands also vary in texture. Go to an art supply store and touch the paper packs or, better yet, ask for samples. Mail-order art supply stores will sometimes sell sample packs, and others have ready-made comics art paper.

Comics art pages come with blue lines printed on them that are the perfect size. You can buy standard-size manga art paper or standard-size Western-style comics art paper.

But just because ready-made comics art paper is available does not mean it's right for you. For example, the manga paper available commercially is the wrong proportion for the Western-style comics I do. It is also not the right *weight* for my needs.

Paper also comes in different weights that tell you how thick and heavy it is. Commercial manga paper is usually about 108 pounds (230gsm), which is too flimsy for me. I prefer paper that is no less than 146 pounds (310gsm) (e.g. Bienfang, vellum [fine], acid-free bristol)

for all my comic art linework. I must have tried fifty types before settling on the one I use, and it's not available with preprinted comic art lines.

My advice is to experiment with many types of paper. You may even find that you like to use different papers for different art. Whatever you do, start off with the highest quality paper you can afford.

TRACING PAPER

Tracing paper is thin, semitransparent paper useful for quick sketches and layouts. While it's not an essential tool, it is very handy, and a number of the exercises in this book use it.

Tracing paper is intended to be disposable, so it's inexpensive. Another option for the economy-minded artist is typing paper. It's sometimes very flimsy and semitransparent, and you can buy a box of 100 sheets for almost nothing. But some people prefer to buy acid-free, high-quality tracing paper to preserve their every doodle. If you can afford to get quality tracing paper, that's great.

ILLUSTRATION PAPER

You're going to do some color work exercises in this book as well. Most of what you will create in color can be done with felt-tip markers, and your drawing paper will work fine for that. But if you can, buy some high-quality heavy-weight illustration paper intended for painting in water-based color media.

PENCILS and Other ILLUSTRATION TOOLS

Every artist has a favorite pencil, and there is no right or wrong pencil for drawing comics. Many cartoonists use a simple mechanical pencil with a 2H lead. It's good to have softer lead pencils as well, such as HB and old-fashioned Ebony brands.

An animation and illustration essential is a non-photo blue pencil. Your computer can be set to ignore the blue lines of the underdrawing and only see the final black lines of the finished work. Since the sketchy underdrawing will magically disappear, the non-photo blue pencil frees you to be loose and energetic with your linework in a way that wouldn't be possible if your sketches were done entirely in black pencil.

Nonphoto blue pencils

When I want my work to look more energetic and cartoony, I use a non-photo blue pencil for my original sketches. When I want a more sedate and illustrative look, I use black pencil for my drawings.

As far as non-photo blue pencils go, I recommend the Sanford Col-Erase Copy-Not. Other non-photo blue pencils have a wax binder that resists black ink lines (preventing ink from sticking to your paper when it meets the binder); Col-Erase Copy-Not does not. This allows you to ink freely over the blue and to erase more easily.

PENS

Different pens produce different results, so most cartoonists keep a number on hand to create different looks. To get started, purchase a few fine-line markers such as Deleters or Pigma Microns, or a few crow quills. Crow quill pens have metal tips that you dip into a jar of ink. The G-Pen crow quill tip, imported from Japan, is a favorite with many manga and Western-style comics artists.

Crow quill pen

ERASERS

Erasers are a must, and anything that gives you a clean sweep is OK. The ugly gray kneaded eraser is an artist staple. Eraser pens are especially handy, too.

Erasers

LETTERING GUIDE

An Ames Lettering Guide is inexpensive and fits in the palm of your hand, but what you can do with it will last a lifetime. This little tool helps you rule perfect lines on your paper for lettering your comic art by hand. Even in the age of computers, this is still necessary (any skill you can do when the power goes out is useful). Also, computer fonts don't always fit your art style. With a little effort, you can make letters that fit your own drawing look.

Lettering guide

BRUSHES

Some artists rarely use brushes, while others do almost all of their inking with them. You can buy an inexpensive set of small brushes at most art supply stores. Do not use your inking brushes for painting, and be sure to use a separate brush for ink correction fluid. Always keep your brushes clean and never let ink or paint dry on them. Good brushes can be expensive and will be ruined quickly if you don't take care of them. As brushes wear out, you can use them to splash down wide swaths of ink.

INK AND CORRECTION FLUID

Get ink that is permanent and waterproof. Correction fluid should be permanent and crack-resistant so it doesn't crumble with age. Japanese imported inks are wonderful and are relatively inexpensive. Other brands to try are Higgins Black Magic Ink and Pro White (for corrections).

Ink and correction fluid

T-SQUARE AND RULER

These tools are must-haves for creating clean borders and perfect angles. Templates for ruling circles and ellipses come in very handy, too, as well as a triangle or compass.

ART TAPE

You'll need cloth, acid-free art tape to hold your art firmly to your drawing board. Never use any kind of permanent tape to do this. In a pinch, masking tape will work and can usually be easily removed, but don't leave it on too long as it will leave brown marks.

Another easy item to use is called drafting dots. They are little circles of tape made especially for commercial art. They're unlikely to harm your paper, but not so easy to find in the average art supply store. Try architect or drafting supply companies.

Art tape

LIGHTBOX

The bright light from a lightbox can make difficult art tasks a breeze, so almost every animator and cartoonist uses one. When you put a picture on it and a piece of paper over the picture, you can see through to the image beneath. A lot of nifty drawing tips in this book require the use of a lightbox, but you can substitute a sunny window for a similar effect.

In a real pinch, turn on your television and tape the art to the screen. The bright light should make your original semitransparent. Be sure not to scratch the glass or screen with your craft knife though!

DRAWING BOARDS AND TABLES

You don't need a fancy drawing table; simply leaning a lapboard against any table will do. The board should have clean, 90-degree edges on which your art will fit comfortably. Always draw with your art tilted at least at a 45-degree angle toward you. Drawing on a flat table surface creates an optical illusion that distorts the image. Hold any picture at eye level, look at it in front of you, then slowly tilt the picture away from you. Notice how this changes the shape of the image you see.

MARKERS AND WATERCOLORS

You can create nice color works using inexpensive markers and paints. Start out with a marker set and a set of beginner's watercolor paints. Eventually, you'll want professional-quality markers and paints. Copic Sketch Markers, though expensive, are great and can be used with an airbrush attachment set. And professional-grade paints with a high rating of permanence (rating of I indicates the highest level of permanence) resist fading better than student-grade paints.

REFERENCE PHOTOS

No matter what the project, reference photos always come in handy. Every professional artist keeps files of photographs and magazine clippings for reference.

Take pictures of everything around you, even the most mundane items: lamps, bathroom and kitchen fixtures, your family car. Then keep files for all the photos so you have them at the ready whenever you need them.

REMOVING TAPE

To remove old or unwanted tape from your art, set a hair dryer to high and hold it over the tape. The adhesive in the tape will melt, allowing you to remove it safely. If any adhesive remains on the original art, rub it gently with your finger while applying heat. The adhesive should roll off as you rub.

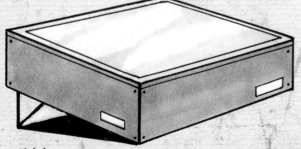

Lightbox

TONE SHEETS

Tone sheets are wonderfully versatile comics art tools. They give your art a lot of pizzazz! Terry Austin, famed inker of the classic Uncanny X-Men tales, first introduced me to tone sheets. He frequently used them to enhance shadows on colored comics pages or to add complex patterns to clothing and backgrounds.

While both manga and Western comics artists use them, tone sheets are used far more often in manga. Most manga are published in black and white, and the line drawings are enhanced with the application of gray areas, patterns or prefabricated backgrounds.

There are a number of comics art programs available that allow you to create your own tone sheet looks or to apply ready-made tones. However, hand-applied sheets are very inexpensive and easy to use. And almost every mangaka I know still prefers some of the hand-applied tone sheet effects to many computer effects, even though computer programs are always improving, adding new effects and are easy to use.

In the long run, it is probably cheaper to use a computer. But in the short run, it is cheaper to use the hand tones. Over time, those hand tones can get pricey. At five dollars a sheet, and 100 sheets used a year, you could be saving for a computer or great new software. But if you're not going to be using many tone sheets, it's cost effective to use the hand-applied sheets.

Learning to do tones by hand is less costly than computer tones, takes less time to learn

and discourages overtoning. (It's easy to get carried away with those computer tones.)

Tone sheets are hard to find in art stores in the U.S., so the best way to get them currently is from import companies. I bought about one hundred sheets in Tokyo in 1996 and still have most of them left, even though I've used them on hundreds of pages of art.

TONE SHEET SUPPLIES

OEL publishers generally prefer to use computer artists for toning because changes can be made more easily. However, artists who are skilled at applying tones by hand can also get work, especially if the senior mangaka prefers the hand-applied tone look.

Another advantage to hand-toning is that your original art looks as pretty as your printed pages. The value of your original art is always something to keep in mind.

So, gather the following materials as you get ready to apply tone sheets:

► LIGHTBOX Any lightbox size that is slightly larger than your original art will do. If you can't get one, tape the artwork to a sunny window.

► CRAFT KNIFE When using this simple knife, be sure to have a fresh supply of sharp blades on hand.

Tone sheets come in thousands of varieties
The plastic adhesive tone sheet is backed by a flexible protective sheet, which can easily be peeled away after you cut the image you want. The image can then be applied to your original art.

- ▶ SAND ERASER This is a special kind of eraser with a toothy surface. You can create an air-brushed effect by rubbing tone off the face of the sheet, which adds highlights to the art.
- ▶ BURNISHER Also referred to as a spatula, a burnisher is a flat, plastic stick. After cutting out a tone sheet, peel off the backing and place it on top of your original art. Rub the sheet with the burnisher to make the sheet stick firmly.
- ▶ GLUE STICK Sometimes the adhesive backing of a tone sheet just won't stick the way you want. A glue stick is useful if you have to remove the sheet and reposition it. Remember to use acid-free glue!
- ▶ HAIR DRYER If you make a mistake with your tone sheet, use a hair dryer to direct heat at the spot you want to correct. The tone sheet adhesive will loosen, and you'll be able to peel it away without harming your art. Careful! The dryer may melt the adhesive in places you don't want it to.

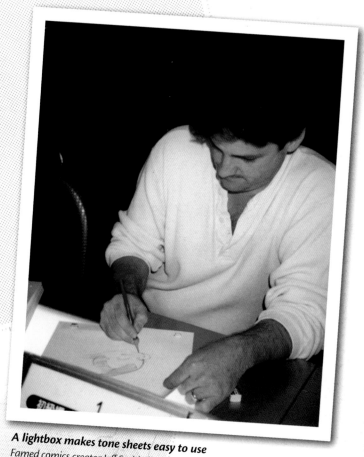

A lightbox makes tone sheets easy to use

Famed comics creator Jeff Smith illustrates how easy it is to use a lightbox. Just place your art on top, turn on the light and start drawing! The bright light will show through your original art, making the page semi-transparent. It's a great tool for making rough drafts, final drawings or applying tone sheets.

Easy-to-find tone sheet tools

Ask any manga art supplier for sand erasers, burnishers, craft knives and tone sheets.

17

SO, what about COMPUTERS?

Whatever you choose to do with your work, computers are a part of the publishing world. So, even if you don't use a computer to create a single page of your comic, if you want to publish, you need a computer.

ELECTRONIC EXPECTATIONS

Creating original art is a great advantage. There is just a great deal of satisfaction that comes from doing something with your own hands. The drawback to original art is that it can be hard to correct mistakes. Sometimes publishers want last-minute changes. And tight deadlines can make drawing complicated pages a nightmare.

I've been a professional artist for years, but I hired a computer tutor to help me with my work because, in the last few years, publishing has completely changed. All my editors want my work delivered on disk, they want changes to my art using Adobe programs, and they want to be able to send me assignments and see art via email. Everything I used to do by sending boxes through Federal Express, I now do with my computer.

LEARNING THE PROGRAMS

Fortunately, you don't need to pay for pricey classes at art institutes to learn to use computer graphics. There are websites that offer video tutorial programs on how to use a computer.

My favorite of these is www.lynda.com. This website has more than 250 tutorials with more than sixteen thousand lessons. To subscribe, you pay a small monthly fee, which allows you to watch as many programs as you want and for as long as you want. I never took a class as useful as these at art school. All the major programs you will use as an artist are covered. While I created most of the art for this book by hand, some was colored or altered using one or more of these programs.

THE ABSOLUTE ESSENTIAL

Even if you never do a single page of art on your computer, you'll still need Adobe Photoshop and a good quality scanner. Later on we'll talk about the size of your original art, and one of the reasons size matters is that small scanners are cheap and big scanners are expensive. Keeping your original art fairly small is a good way to avoid a big scanner price.

A scanner is essentially a fancy photocopy machine, except it makes copies onto your computer instead of onto a piece of paper. You lift the lid and place your art onto the surface (called a platen), close the lid, press a couple of buttons in Adobe Photoshop, and voila! A picture of your art appears on your computer screen.

Scanning art for a publisher is more complicated, and how you scan it depends entirely on its size and how it will be used. And it takes some practice.

Much of my original art for clients is done entirely by hand, but I still scan it onto my computer, correct small mistakes in Adobe Photoshop, create a file, and then email it or send it via disk.

A lot of art used to be lost, damaged or stolen at publishers; I don't know of any professional artist who is not grateful that scanners are a part of our daily lives.

OTHER USEFUL PROGRAMS

There are several programs that comic book artists use, and the one I'm hearing raves about is Manga Studio. You can order the "debut" version for a low price, but you will need to get the professional version for the best quality work. Many mangaka love this program because it handles many tasks in one handy package: inking, lettering and applying tones, as well as creating page layouts for preparing

Don't give up your pencils!
Even if you already have all the computer equipment, software and training you could possibly need to create your own comics, you should still know how to draw by hand. I feel very sad when I meet artists who simply can't draw without a computer. (I wonder what they do when the power goes out.)

a book for publishing. The tones do look different on screen than they appear in print, though. Western comics artists can create black-and-white drawings in it, but need another program to color.

Some artists prefer Poser. This one helps to design highly realistic figures and create models in a number of poses. Beware: Overreliance on computers for your figure drawing can result in stiff, plastic people who lack life and energy.

SketchUp enables you to create three-dimensional environments quickly and easily. Some artists I know use SketchUp for the underdrawings of buildings or machines, print them out, then trace over the computer drawing on their original art paper, adding details by hand. This allows them to create an in-perspective drawing without going through all the time it takes to work out the perspective. The beginner version of the program is available for free at the company website. The professional version is pricier but worth every penny.

Comicworks is available from Deleter, the company that produces many of the tone sheets manga artists use. Most mangaka tell me that the tones on this program are the best. Unfortunately, there is no Macintosh version.

Keep in mind, too, that whatever software you have will need to be replaced periodically with the latest software your publishers are using. In fact, one of my editors told me a sad story

recently: A letterer she had hired had not been staying up to date with industry standards. The editor had to replace him because they could not use his computer files at all.

You, the artist, must stay up to date with your equipment and training. I study more now than I ever did when I was in school! You must balance the investment in the computer equipment and training you'll need, with the payoff you'll get from the speed and convenience of the computer system.

BASIC PRO SHOPPING LIST

- ▶ A computer with the most memory capability you can possibly afford
- ▶ A scanner that can scan black-and-white art at up to 1200 dots per inch (dpi)
- ▶ A laser printer that can print at least 600 dpi
- ▶ The largest computer monitor you can afford
- ▶ An external hard drive of some kind for keeping duplicate files and records
- ▶ A CD burner
- ▶ Adobe Photoshop, InDesign and Illustrator
- ▶ An Internet hookup—DSL or satellite

PRO TECHNIQUES

Most of what you learn to do by hand translates into skills you can later use on a computer. However, a lot of computer skills don't necessarily pay off in work you may do with paints, pencil and paper.

For example, getting smooth gradation of color over a large area of art with the computer is very easy, and it's a technique that takes minutes to learn. However, painting that same area by hand with a brush can take hours, and it can take some time and effort to get handy with an airbrush. Just because you know how to get great final results on the computer doesn't mean you can get great final results by hand. It's so easy to correct mistakes on the computer that some artists never learn to develop sharp fine-motor skills. Even if you work on a computer, always take time to draw by hand as well.

PERSPECTIVE

The appearance of depth and the technique of creating three-dimensional drawings on a two-dimensional surface is called *perspective*. You need to know perspective basics in order to draw properly. You won't learn all you need to know here, but just a few perspective lessons can get you on your way to drawing manga and comics.

You can draw anything in perspective by paying attention to the horizon line, vanishing points and orthogonal lines.

Two-dimensional drawings look flat

Perspective adds depth
The farther away something is, the smaller it looks. This rectangle appears smaller as it approaches the horizon line. The two red lines (called orthogonal lines) along the sides of the rectangle point toward the horizon and vanish at a single point called the vanishing point.

Horizon line
As we look out toward the sea, everything within view gets smaller until it disappears. This is the horizon line.

Keep your eye on the horizon line
The relation of the viewer to the horizon line is called the vantage point. Images seem to change depending on the vantage point from which they are viewed. An image that appears to be below the horizon line is being viewed from above, for example. Notice how the shape of the cube appears to change depending on how high or low the cube is in relation to the horizon line.

Drawing in one-point perspective

It's helpful to practice drawing in perspective on something simple. Every structure and mechanical object you will ever draw starts with this basic, step-by-step process.

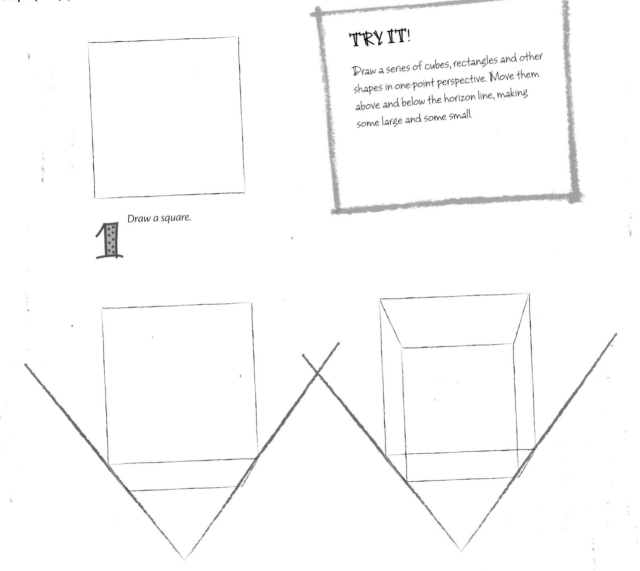

TRY IT!

Draw a series of cubes, rectangles and other shapes in one-point perspective. Move them above and below the horizon line, making some large and some small.

1 Draw a square.

2 Put a dot on the paper to represent the vanishing point, then draw two orthogonal lines to meet the edges of the square. Now draw the lines of a second square on top of the orthogonal lines.

3 Add the far edge of the cube. You have now drawn a cube in perfect, one-point perspective. You can make the cube appear more three-dimensional by drawing the inside following the same process you used on the outside. Draw the inner lines to point toward the vanishing point, and draw the side lines of the cube parallel to the original side lines of the square.

Drawing in two-point perspective

If you look at pictures of buildings, you'll notice that one side of a building gets smaller in one direction, and the other side gets smaller in the other direction. In two-point perspective, orthogonal lines recede to two separate vanishing points along the horizon line.

TRY IT!

Look around your house for simple objects that you can draw in two-point perspective, such as books or tables. Draw at least ten of these objects from three different angles.

Then, move on to drawing a picture of a building from at least three different perspective angles.

CITYSCAPE AT EYE LEVEL

1 *Draw a horizon line with two points. Draw orthogonal lines radiating from both points.*

2 *Draw the basic shell of a cityscape. All the lines of the buildings on the left follow orthogonal lines to the left vanishing point, and all the sides of the buildings on the right follow orthogonal lines to the right vanishing point. Draw the edges of the buildings straight up and down. The bottoms of the buildings should sit directly on the horizon line.*

CITYSCAPE FROM ABOVE

1 *Viewing the city from above the horizon line, the orthogonal lines will be both above and below the horizon line.*

2 *Again, the basic shell of the city has all the left-hand buildings pointing toward the left-hand vanishing point, and everything on the right-hand buildings pointing toward the right-hand vanishing point. Only in this shot, the lines go above and below the horizon line in a big diamond shape.*

23

PEOPLE in PERSPECTIVE

Here are a few tips to get you started drawing the human form in perspective.

Arrange figures within orthogonal lines

People are subject to the same laws of perspective that buildings are. They appear smaller as they move farther away from us. This is called foreshortening. A line of people who are the same height will stand with their feet on the bottom orthogonal line and their heads touching the top orthogonal line, and both lines will meet at the vanishing point. Imagine these people standing in a hallway or in a crowd.

Hang figures along the horizon line

To place a group of characters in a shot, "hang" them on the horizon line by drawing every person so that the horizon line crosses them in the same place on their bodies, whether they are close or far away.

Here, all the characters cross the horizon line at their waist, except for the character farthest away. The horizon line crosses him at his chest. Why? He's shorter. If he were standing directly next to any other character in the picture, he'd come up to their shoulder! Test this for yourself: Draw two orthogonal lines to the horizon line from our short guy to any other figure in this shot. Note how his head would only come up to their shoulders!

TRY IT!

Draw the perspective body chart in your sketchbook. After you've tried it, vary the angle of the body slightly and draw it again from several different perspective angles. Then, draw a group of three people standing outside a building. Make one of the people very far away, one in the middle of the shot, and one closeup.

Perspective body chart

Use this chart to help you draw the human body in proper perspective.

Penciling

For this exercise, you'll need a non-photo blue pencil, a 2H graphite pencil and photocopier or computer. Follow the head sketches or create your own drawings to see just how much freedom these tools can give you.

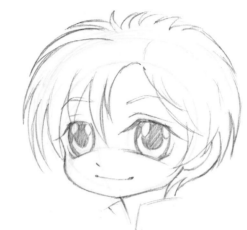

1 *Beginning with a non-photo blue pencil, block in what you want to draw, being very free with your scribbles.*

2 *Use a simple 2H graphite pencil to sketch your final drawing right on top of the blue pencil.*

3 *Clean up with Adobe Photoshop or a photocopier. Turning down the blue channel in Photoshop makes the blue lines disappear. This saves a lot of time erasing and tightening up your work.*

On a copy machine, your blue lines will still show up, but they will be a lot lighter than ink lines or dark pencil. If you adjust the brightness or darkness button on the copy machine, you can make them disappear almost entirely.

EXPERIMENT with INKING TECHNIQUES

Practice using markers, technical pens, crow quills and brushes to learn what tools you like best. Don't be afraid to make mistakes. If you're worried about messing up your original pencil drawing, use a lightbox. Place your drawing on the box and put a blank piece of paper on top. When the light is on, you'll see your pencil drawing underneath and can then trace it on the top sheet of paper without touching it.

Inking with markers and pens
Markers and mechanical pens create clean lines and even strokes, giving your art a sharp, defined and elegant look. You'll need a variety of sizes to produce different line weights, as they offer a lot of control, but they don't give the line much character.

Inking with brushes
Inking with brushes takes practice but offers great rewards: You can vary your line weight and style by simply changing the amount of pressure you use, allowing you much more variety. The lines are not as controlled as the pen, but they are lively and interesting in a different way.

Inking with crow quills
It takes some time to master, but crow quill pens give you effects somewhere between that of a regular pen (with its immobile line) and a brush (with its style variations).

26

How You Finish is Up to You

You can give your art any look you like. You don't have to ink it; you don't have to color it. But you may want to take the time to try out a lot of different types of art styles and tools before you choose a look and technique that is right for you. Using the same picture, notice how different each of these drawings looks. You can use these techniques or mix and match different techniques in one picture.

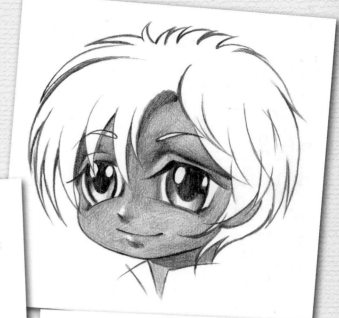

Finished pencil drawing
This is a fully rendered pencil drawing. I love the halftone look and have completed entire comics this way. It's a difficult technique and few attempt it, but it gives the art a unique quality and is more fun than doing tones on the computer.

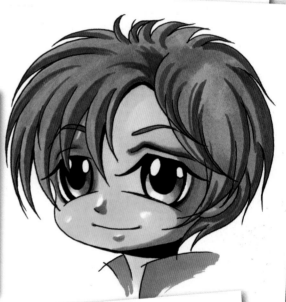

Hand-colored drawing
Hand-colored (or painted) art is fun and easy to create. You can produce very finished looks with nothing more complicated than a felt-tip marker, which is what I used here.

Computer-colored drawing
Computer-colored art is now the industry standard in monthly comics. Most artists don't color their own work. Professional colorists train for a long time to get beautiful effects. I recommend that you learn to color by hand and on a computer. I used the easiest and most basic computer coloring here, completing the job in less than ten minutes.

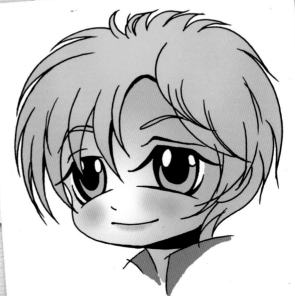

Getting started with tones

Applying tone sheets is quite easy. Almost anyone can learn to do it in less than an hour. There are no special skills required to master this simple technique that will enhance your comic art for years to come!

BASIC TONES

1 Draw a circle, then place your art on a lightbox and turn on the light.

2 Place the tone sheet on top of the paper. You'll be able to see the circle image through the tone sheet. Using your craft knife, carefully cut around the circle shape. Cut an area larger than you need. Don't cut so deeply that the knife goes through the backing of the tone sheet.

3 Carefully peel the tone sheet from its backing and place it on your original art. Using a craft knife, cut away the excess tone sheet.

4 Using a sand eraser, rub highlights from the tone sheet. The little black dots will disappear like magic and give the circle a rounder look.

HAIR TONES

 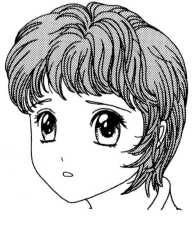 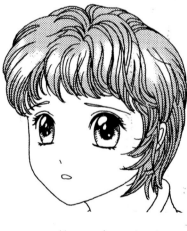

1 A lot of manga art uses line to depict the flow of hair, but working in tone suggests form. Think of the hair as a mass, not as a series of lines.

2 Using a craft knife, cut carefully around each strand of hair.

3 Use a sand eraser to rub out highlights.

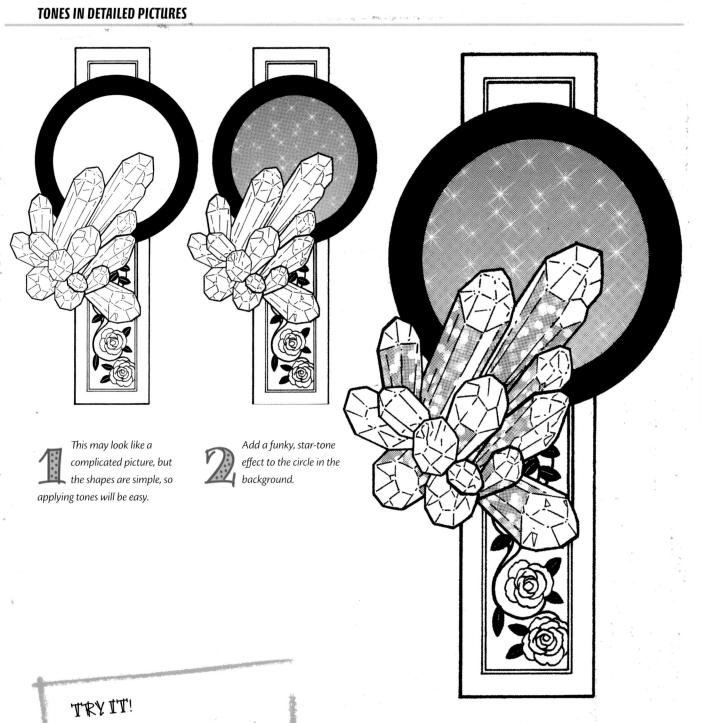

1 This may look like a complicated picture, but the shapes are simple, so applying tones will be easy.

2 Add a funky, star-tone effect to the circle in the background.

3 Add sparkle-tone effects in strategic places on the foreground crystals to make the picture shine.

ART FROM **A DISTANT SOIL** © AND ® COLLEEN DORAN 2007

TRY IT!

Copy any of the drawings on these pages to practice tones, or add some tones to your own drawings. Try different types of tones for different effects. If you're worried about damaging your original art, make photocopies of it and apply the tones to the copies until you're comfortable adding them to your originals.

USE TONES on BACKGROUNDS

One of the most useful applications for tone sheets is in creating backgrounds. Sometimes manga artists use computer-generated tone sheets with pictures of cities, schoolrooms and homes to avoid drawing complicated backgrounds by hand. It's so easy to cut and paste in an instant background tone. But remember: Overuse of this technique is a sure sign of an amateur. Any artist can use the same backgrounds you do. Limited use of instant backgrounds is just fine though, and can save you a lot of time.

Instant backgrounds make for fast work

To place a figure on a background tone, place the tone sheet on a lightbox, then place a blank piece of paper over it. You'll be able to see the tone sheet through your paper and to properly position the figure in the background.

Voila!

Place the tone sheet back on top of the paper on which you drew the figure, then cut and position the tone. The figure appears to be standing in a perfectly drawn scene. It's a great look. Some artists create their own backgrounds on computer, achieving the same look as this tone.

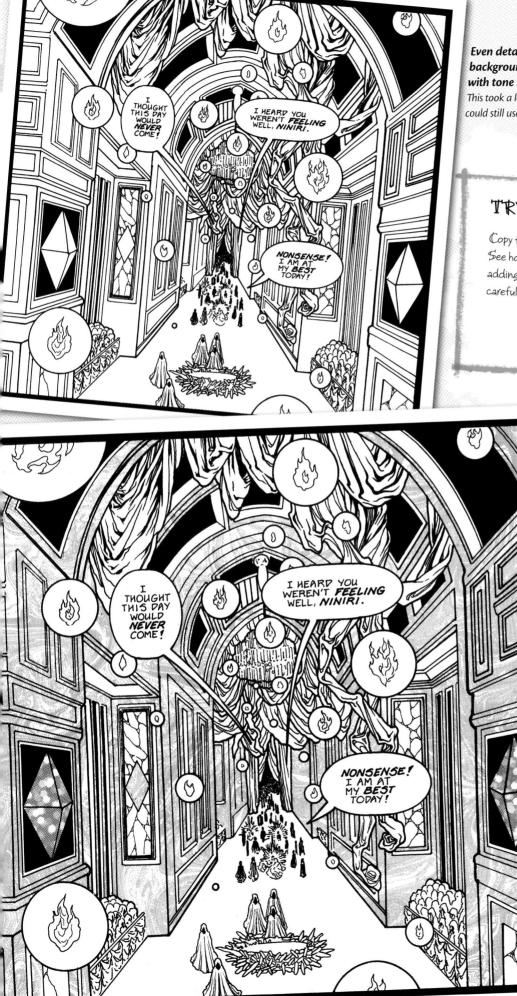

Even detailed, hand-drawn backgrounds can be enhanced with tone sheets
This took a lot of time to render, but it could still use some extra detailing.

TRY IT!

Copy the untoned illustration on this page. See how many different looks you can get by adding tones to the background, and practice carefully placing small tones.

The computer helps isolate details

Marble tone sheets, carefully cut and pasted onto the walls, add flash to the image. Sometimes it's faster to cut and paste tones by hand, but this scene is one instance where adding tone by computer is much easier and faster. Tiny details can easily be isolated and added using the magic wand tool in Adobe Photoshop. It would be very tedious and tricky to cut and paste all those little bits of tone by hand, especially when you are adding sticky tone sheets side by side! It's very easy to accidentally pull them apart.

ART FROM **A DISTANT SOIL** ©
AND ® COLLEEN DORAN 2007

31

Practicing tone work

Now that you've had lots of practice applying tones, experiment with this picture. Some companies also sell Copy-Tone sheets, or blank sheets of tone plastic. You can create your own drawings or patterns and then run the Copy-Tone through a copy machine. Your handmade tones will copy onto the Copy-Tone sheet. Additionally, you can create hundreds of original tones using a computer.

 Make a larger copy of this line illustration.

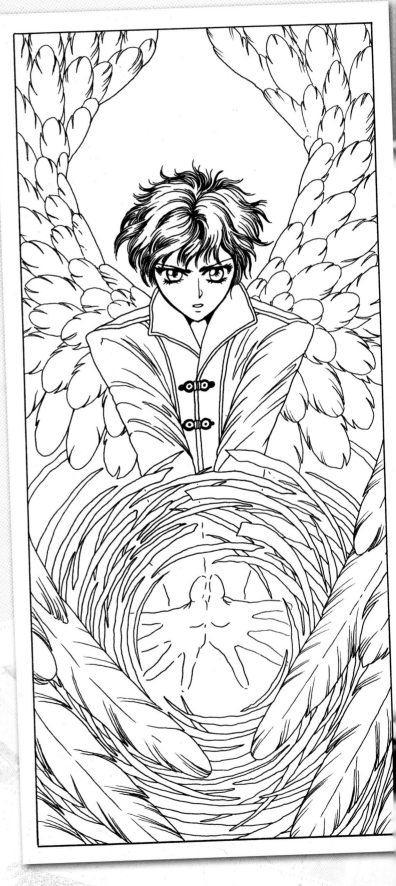

2 Create as many tone looks as you like. For example, instead of using a planet behind the head, how about a sky pattern or a flower pattern? The picture would feel really different if flowers were in the background.

CREATE MOOD and SYMBOLS with TONE SHEETS

Artists around the world use symbolism in comic art. Using objects and images to represent relationships, to portray hidden depth, or to give an image a double meaning is an important element of manga. Flowers spontaneously appear in backgrounds, odd shapes emerge, and objects are prominently displayed in backgrounds to enhance the meaning of the action. Symbols give the reader clues to characters' thoughts, and even their ultimate fates. Using tone sheets is a great way to achieve these effects. Changing the background element of a picture can completely change the meaning of the image.

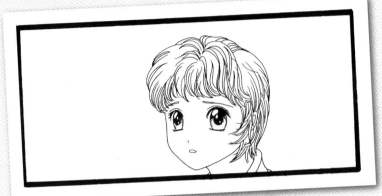

Blank slate
What is this person thinking? What is going on here? We don't know. It's just big eyes. Perhaps she stubbed her toe. You can't tell from this picture!

Lost in thought
Add a hazy background, and the picture suddenly changes. The diffusion behind the face gives the character a "suspended in time" look, as if she is lost in thought. While she may have been lost in thought in the blank panel, here the meaning is more obvious.

Enraged
The lightning bolt background in this panel makes it appear as if our cherubic friend is about to explode in anger.

34

In love

There's no mistaking the meaning of this flowery background: This person is stupefied with love! You can almost smell the perfume. The character seems to be staring at the object of her adoration off-panel.

Surprised or stunned

Our friend is plainly and simply stunned, perhaps by the terrifying realization that she forgot to bring her homework. Whoops!

Wonderment

Lovely snowflakes drift down in this picture to give the image a sense of wonder. The character's face seems to be gently captivated by the scene.

Otherworldly

Usually, I use this marble background for the purpose for which it was intended: to create marble effects on stone. But here, it really makes this character look as if she is having a psychedelic episode.

TRY IT!

Make copies of the panel with the blank background on page 34. Create new backgrounds to change the meaning of the picture. Use tone sheets (or draw your own original background ideas) to create at least five different new pictures. Consider how different types of symbols—flags, plants or a raised human fist, for example—affect the expression and meaning in the picture.

Embarrassment or friendship

Different flowers provide a completely different impression. Simple daisies can indicate friendship or that a person has just had an embarrassing moment. A background of spontaneously generating daisies, for example, is ideal for someone who has just said something completely (and innocently) inappropriate at a formal dinner.

Combining tone and drawing

By now, you've had plenty of practice using tone sheets. But it doesn't end here! For extra-special effects, consider combining tone sheets with more rendered drawings or shapes. In this exercise, you'll combine a tone sheet of shooting stars with your own drawing to come up with yet another look.

 Draw straight lines surrounded by a sketch of swirls.

 Make a series of double or triple ink lines on each side of your original pencil lines. Give the lines a ghostly, delicate form.

Lay the tone sheet directly on top of the drawing. Using a sand eraser, rub out some of the tone sheet to accent the swirls. Use a craft knife to scratch out areas you want to appear sharply defined. The final art is very attractive and powerful-looking!

ART FROM **A DISTANT SOIL** © AND ® COLLEEN DORAN 2007

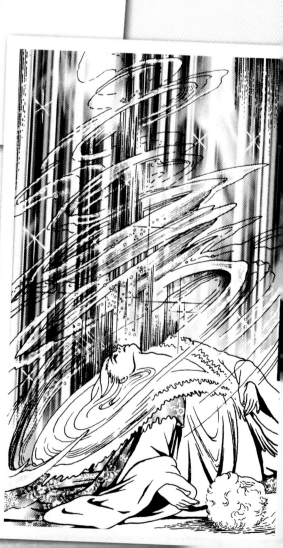

Use the SIMPLE to CONVEY the COMPLEX

All the key information in comics can be conveyed with symbols and stick figures. In fact, your work is most effective if it can be read in a simple form. Add all the detail you want later, but make sure that your work is clear and concise in the earliest stages of design and composition. If it's correct when it's merely a doodle, then it will be correct when you finish the page.

These thumbnail drawings represent movement, feeling and emotion. They convey everything the reader needs to know.

Surprise

Heartache

Sadness

Speed

Shock

Growth

Isolation

Touch

Overwhelm

Joy

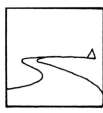

Sound

Rest

Expansion

TRY IT!

Fill ten pages with ten 1-inch (3cm) squares. In each square, draw a different, simple icon symbolizing only sad emotions. The next day, repeat the exercise, this time showing speed. The next day, show taste. The next day, show joy. Every day, concentrate on a different theme, and try to make your icons as different from each other as possible.

The ART of LETTERING

Nothing in comics is more ignored when done well, and more obvious when done poorly, than lettering. While it may be a skill you don't care to learn (and we're not going to spend a lot of time on it), you'll want to understand the basics.

There are lettering programs, and they're great. There are professional letterers, and they're great, too. But if you're creating a comic from scratch, you still can both afford and handle a few hours' practice and an Ames Lettering Guide (see the next page).

Ames Lettering Guide

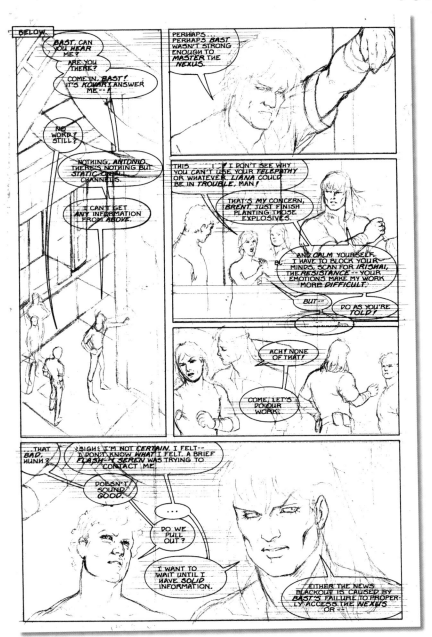

Japan's answer to Ames
This block of squares is used for shaping and placing Japanese words into manga. Japanese is usually written from right to left and from up to down in columns

Japanese word balloons
This works for Japanese manga because it's written and read in this shape.

Please . . . no Japanese balloons for OEL manga
Often, OEL artists try to make their word balloons look like Japanese manga word balloons. I hate to tell anyone that they can't or shouldn't do something, but . . . please don't do this. Your OEL readers aren't reading in Japanese, and this makes reading English words difficult.

Advantages and disadvantages to hand-lettering
Because you'll add lettering and word balloons at the pencil stage, you save yourself a lot of drawing. The big disadvantage to hand-lettering is that it's a lot of work to redraw art that has a word balloon you don't want on it. Sometimes, erasing pencil lines also erases some of the lettering ink, leaving you with washed out words.

Using the Ames Lettering Guide

Anyone can learn to use an Ames Lettering Guide. The circle in the middle of the guide is movable. At the bottom of the guide at the bottom of the circle is a small mark. You will also see a series of numbers at the base of the guide. By turning your circle, you can create a series of lines that will be bigger or smaller, depending on the size of your art. My art is fairly small, so I set mine at about 3.5mm.

A series of curved lines follows the row of dots

Use the holes at the end of the curved lines to make lettering lines. The hole at the top is called a spacer. When you start a new row of lines, place the spacer on the last row you drew. The new lines you draw under it will be perfectly spaced for your letters.

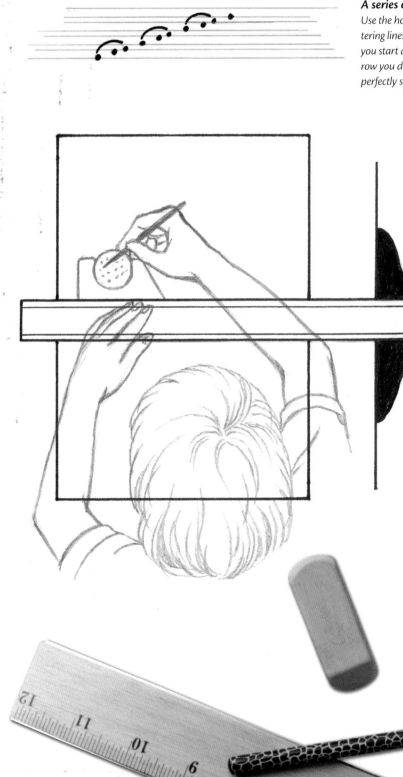

1 *Place a T-square on your paper, making sure the T-square is perfectly positioned along the edge of your drawing board. Hold the T-square firmly in place, and put your pencil into the top dot in the second row of holes in the lettering guide (some people use the bottom row of holes). Sweep the guide across the paper, placing your pencil in the next hole as you sweep back.*

2 *You should end up with a series of lines on your paper like this. You have created a perfect set of lines for lettering, with precise spaces between each row.*

3 *The wide lines are for placing letters; the narrow lines are the spaces between the letters. Using a thick pen (a Deleter Neopiko Line .5) and a thin pen (a Deleter Neopiko Line .3), you can create two types of letters very easily. The dark letters are for emphasis.*

Placing word balloons

No matter how pretty your pictures are, no one will see them if they're covered up with word balloons. Whenever you can, place the word balloons first.

1 Determine how much space you'll need and sketch in the word balloon shapes using a non-photo blue pencil. If you have trouble deciding how much space your words need, letter some words on a separate sheet in a typical comics word grouping. Hold it next to your paper to see how big ten, twenty or thirty words will be.

2 Place the sketch on a lightbox, then position a clean piece of tracing paper over the word balloon sketch and begin doodling your panel idea sketch on the tracing paper. Move the tracing paper around to see how all the elements of your drawing will fit.

3 Place the tracing paper under the paper with your word balloons. Draw this stage using the blue pencil, too.

4 Refine and tighten your final sketch. The word balloons are exactly where you want them, and they fit your composition. Now there is no need to worry about trying to make your picture fit in that box with the balloons, or making the balloons fit around the picture.

WORKING in COLOR

Most comic book artists never work in color. Manga artists often only work in color on cover art, and Western comics artists produce color comics that are created by a team of people, one of whom does nothing but color comics.

Even if you don't have to do your own comics in color, it doesn't hurt to learn and practice coloring. You don't need any special equipment—with a few exceptions, all the color art you see here was created with felt-tip markers. If I can do it, you can do it! Before we move on to creating comics pages, we'll take a moment to become familiar with some coloring basics using markers.

Experiment with coloring options

This illustration was created with nothing more complicated than photographs and colored pencils. The photographs were cut apart and copied onto watercolor paper, and pasted onto bristol board. Then drawings were done directly on top of the copied photos with colored pencils. The lines were created with inexpensive graphics tape. There are many different ways to create color works, so don't just limit yourself to using what you see. Try to come up with new looks for yourself.

Coloring: begin simply

Getting smooth colors with markers can be tricky. The better quality marker you can afford, the better quality the finished work will be. To ensure smooth, clean strokes, use the wide tip of your marker in smooth swaths right next to one another and color as quickly as you can. If you can draw each line while the previous line is still a little wet, your colors will go on more smoothly.

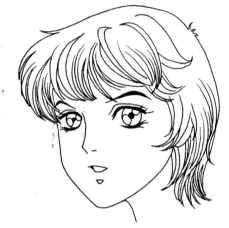

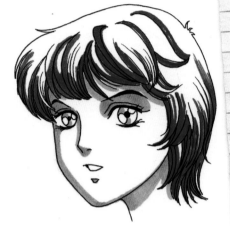

1. *Start with a clean, black-and-white ink drawing on high-quality paper. (If you use cheap paper, the paper will wrinkle when you add color.) Use one of the drawings you've already made, or create a new one.*

2. *Using a light-caramel marker, draw in the shadowed areas of the face. Add pale green for the eyes, and a dark reddish brown for the shadows of the hair.*

3. *Use a peach tone and very smooth strokes for the rest of the skin to make a fresh complexion. Leave a little area of plain white paper on the cheek for highlight. Add a second, darker green to the eyes. Add strokes of a lighter brown to the hair leaving white areas of the paper to shine through for highlights. Pretty easy!*

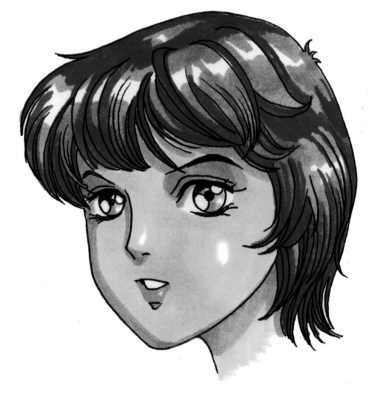

Coloring a figure

Coloring a large drawing of a head can be tricky because you want to give your character a smooth complexion. A figure drawing may not require as much careful smoothing technique, but you do need to pay attention the folds of cloth. Even though the figure is wearing fairly tight clothes, the wrinkles and texture of the clothes should be suggested.

1 *Start with a clean, black-and-white ink drawing.*

2 *Outline the dark areas to create shadows. Use the same skin and hair colors you used on page 42, but add a deep blue for the jeans. Use a greenish yellow for the shadows. Use the same brown on the shoes that you used on the hair. Pay attention to the light source: If the light source is hitting the right side of the cheek, then it should hit the right side of the legs and shirt.*

3 *Add a pale yellow to finish off the shirt, a pale blue to finish off the jeans, a paler brown to the hair and shoes, and a flesh tone to the skin areas that you haven't already colored in shadow. Leave areas of the pants blank for highlights.*

STORY and CHARACTER DESIGN

Character is plot and plot is character. You may come up with a great idea for a character design and be able to dream an entire story around that drawing. Or, you might carefully construct a plot and then decide what your characters look like later.

Chances are, when you're just sitting around with friends or daydreaming on the bus, you have no trouble coming up with a million great story ideas. But sometimes those ideas vanish when you sit down in front of a blank piece of paper. Writer's block can strike anyone at any time. Even if you have a strong desire to create a graphic novel, you may have trouble formulating story ideas.

Here, you'll learn some ways to form and execute your ideas, as well as some basic scripting guidelines to follow.

Brainstorming for your story

Every writer has a different way of approaching the writing process. My personal method is very organic because I often write and draw my own work. Follow the steps to get a feel for the process.

TRY IT!

For the next week, write down the events of your day in short sentences in a journal. At the end of the week, write these events on separate slips of paper. (Use at least fifty pieces of paper.) Put the slips into a bowl, then pull them out in random order. Using the first ten slips of paper, write down the day's events and come up with a story plot. Using the next ten slips of paper, come up with another plot and so on.

I walked to school. Saw a man feeding pigeons. He was old. He was wearing a tattered coat.

Met Josh on school steps. He was really grumpy. He hadn't slept. Didn't say why.

I forgot my homework! I begged the teacher to let my mom bring it later.

Julie told me she broke up with her boyfriend. She was very angry. She was sure he was cheating on her.

Someone kicked the door on Josh's locker so hard it jammed.

I forgot my homework! I begged the teacher to let my mom bring it later.

Someone kicked the door on Josh's locker so hard it jammed.

I walked to school. Saw a man feeding pigeons. He was old. He was wearing a tattered coat.

Met Josh on school steps. He was really grumpy. He hadn't slept. Didn't say why.

Julie told me she broke up with her boyfriend. She was very angry. She was sure he was cheating on her.

1 *Keep a notebook with you and write down everything that happens during your day. Don't just note what happens to you—pay attention to the people and things around you.*

2 *Write down each incident on a separate sheet of paper, then mix them up. Change the order completely. Now, what do you have? Moving incidents around helps you to see your day in a new way. There are plenty of ideas for a story here.*

Turn your notes into CHARACTER and PLOT

The incidents on page 45 contain all the elements of a romantic drama with three main characters; I'll call them Audra, Kacey and David. With a little imagination, you can come up with a plot from the bare bones of the incidents listed, as I've done below.

DRAMA

The day starts off badly for Audra. When she gets to class, she realizes she forgot her homework. She begs the teacher to let her leave class to call her mom. She runs into her friend Kacey in the hallway.

Kacey is kicking at the door of her boyfriend David's locker.

Audra stops her, yelling, "What's wrong with you? Stop that!"

Kacey is furious with David. She ran into him in the park that morning. He was sitting alone, feeding the birds, as he often did early in the morning. He liked to go to the park to play his guitar.

Kacey wanted to talk to him. She suspected him of cheating on her, but he denied it. Kacey did not believe him. They had a terrible argument.

"I know he's lying," says Kacey. "He says he loves me! Why can't he tell the truth?"

Audra is shaken by Kacey's anger. "Where's David?" she says.

"I don't know," says Kacey. "I don't think he came to school."

Scared for David, Audra runs out the doors of the school and sees David sitting on the front stoop in despair.

"Audra," he says, "I love Kacey. But I love someone else,

too. What's Kacey going to do when she finds out the other girl I love isyou?"

This is the plot-with-dialogue (see page 48) for an entire shoujo manga graphic novel. Everything you need is here: main characters, what, where, why, when, and plenty of dramatic conflict.

PLANNING

How much space do you devote to each action? Each scene? Each dramatic moment? If you devote too much space at the beginning of your story to introducing characters, you may not have enough left for your big climax.

Go through your plot and assign each moment a letter from A to C to indicate how important it is to your story. That is, very important scenes get an A and less important ones get a C. As you plan your story pages, you can delete scenes that get a C to give you more time to devote to A and B moments. Then go through and arrange the moments in sequence.

A useful tool for plotting your story is a page plan, also known as a bookmap. It's basically a sketch of your book, with rectangles that represent pages. For a 128-page book, you would have 128 rectangles. You would reserve pages at the beginning and end for front and back matter (the title page, copyright page, etc.), and your main story would take up the rest of the space.

Page plan or bookmap
Make several copies of your blank page plan so you can make as many changes as you like. You can also use them for other projects.

SCRIPTING STYLES

There are many different methods to create a script. Different creators in different situations have different preferences. Try all the techniques a few times to see which one works best for you.

SHITAGAKI METHOD *Shitagaki* is Japanese for rough copy, draft or pencil manuscript. The shitagaki method of writing stories (referred to as layout script by many Westerners) is a way to break down your story and make changes quickly and easily. This rough doodle tells the artist everything she needs to know to draw the story. This method is common in Japan and with graphic novelists who write and draw their own work. You can even make small thumbnail drawings that fit into the boxes of your page plan so you can see how the pages look when laid out side by side.

TRY IT!

Using the plot with dialogue on page 46, draw a series of shitagaki breakdowns. Draw three versions of each page. Draw the pages so that the scenes fit in only five pages. Then draw the same scenes to stretch out over ten pages. Remember: These are sketches, not finished pages.

14

Kovar hit

staggers back into wall

he's down

Sere gloating

Kovar starts to rise

He glares at her over his shoulder

Panel ① Sere: You can try.
Panel ② silent: Sere glares.
Panel ③ silent: Kovar stares.
Panel ④ Sere strikes first with a mental blast.
 Kovar staggers back
 Kovar - Ugh!
Panel ⑤ Kovar is against the wall really being pummeled
Panel ⑥ Sere gloating at her impending victory.

Use the shitagaki method for yourself
When writing and drawing for yourself, you really don't need drawings tighter than this to plan your story. However, if you're submitting your work to an editor for approval during the creation of your book, they'll want to see more complete sketches.

As you can see, I'm not so careful with my doodles. This one even has a big coffee stain on it!

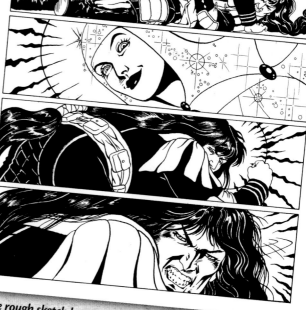

The rough sketch becomes a finished page
The finished, published page closely follows the original layout, though I did make some minor changes. It's all part of the process.

Adapting shitagaki for an editor

Editors need more detail in your shitagaki. This is still a loose drawing, but it has enough detail to convince the editor that he is looking at heads and not amorphous blobs.

This is the most organic working method, and yet it still gives your publisher enough information so that she knows what you intend to do.

PLOT WITH DIALOGUE

In the plot-with-dialogue scripting style (see page 46), you provide the action and dialogue of the characters, but no page numbers or panel breakdowns. It's best suited to artists who write and draw their own work, or to a writer-artist team that works closely. If a writer gives you a story in this style and you don't have him or her nearby, you have to figure out what fits onto which page for yourself. You have to answer questions such as:

▶ How much dialogue should appear on what page?

▶ How many pages are necessary for this scene?

If the writer or editor isn't giving you some direction, you have a challenge ahead of you.

CONTROL THE EMOTIONAL WAVES
A good rule of thumb is to break down the story into a series of snippets that I call *emotional waves*. Go through the story and look for peaks and valleys in the drama. About every twenty-five comic pages or so, let the drama climax and then drop. If everything is a peak moment, nothing is a peak moment. Contrast excitement with moments of tranquility. Let an emotional wave carry you through to the end of your tale.

Segment each twenty-five-page installment, or emotional wave, into chapters, even if you don't use chapter headings (as many graphic novels don't). Then you can break down your tale further into individual pages. It's intimidating to break down 120 pages, but not so hard to think about twenty-five pages at a time.

PLOT/MARVEL STYLE

The plot/Marvel style is so called because it was popularized at Marvel Comics by Stan Lee, who often wrote stories for top artists like Jack Kirby. (An entire page of Lee's plot for a comic might consist of no more than a sentence or two of description: *Page 6: David runs down the steps as Kacey sees him through the window. She turns and screams down the hall.*)

A plot is a rough breakdown of a story idea. For a twenty-two-page story, I've received plots that were no more than five pages long,

included no dialogue, and merely described the action. In a situation like that, the pencil artist is charged with the task of breaking down the story into pages and panels, and figuring out exactly what goes into the panels. The pencil artist then returns copies of the completed pencils to the writer, who then writes the dialogue, closely following the pictures.

In cases where the plot is very loose, artists sometimes get co-writing credit. I've worked on comics where I received no more than a few paragraphs of description for an entire issue. (Major publishers, sometimes pay a higher page rate for this.)

Some artists enjoy this approach because it gives them a lot of freedom. Basically, they cowrite the story. Other artists hate it because they're saddled with the task of coming up with a lot

of the story themselves. It's purely a matter of personal preference If you prefer to have a lot of "wiggle room," you may want to stick with the plot/Marvel style.

FULL SCRIPT

This is the opposite of the plot/Marvel style. A full script can read like a film script or a play. Each page and panel is broken down, and every action is described. Some writers, such as Alan Moore, write an entire page of description for one panel. Others may write no more than a sentence.

WHAT MAKES A GRAPHIC NOVEL?

Most American-style graphic novels are reprinted from comic books—so are most manga. Manga are published in Japan as book collections after they've appeared in weekly or monthly comics. The stories are serialized in installments of anywhere from twenty to forty pages. Most American-style comics are serialized in twenty-two-page installments.

 bradley
 You draw like a girl.

 maggie
 (beat)
 Come again?

 bradley
 A girl. You draw like a girl.

 maggie
 As opposed to?

 bradley
 You know what I mean.
 maggie
 I have no idea what you—

 bradley
 —Our readers don't
 respond to girlie art.

Maggie darts a look at a poster, amid many papering the walls, depicting an anatomically impossible woman hacking a huge serpent with a mammoth sword. The woman wears high

Plot-with-dialogue scripts work well for writer-artist teams
This is a sample of a page of work written by Keith Giffen and me for a project called Meanwhile. If you're writing and drawing your own work, or collaborating closely with a writer, this is a fine way to work.

FROM **MEANWHILE** © AND ™ COLLEEN DORAN AND KEITH GIFFEN 2007

 Page 12

 Panel 1:

 Establishing shot: The ladies bathroom at the school.

 OP: "Kacey are you all right?" (OP means off panel. That is, the dialogue from the word balloon is coming from someone who is not seen in the shot.)

 Panel 2: Kacey is standing at the sink, looking down at her hands.

 Kacey: I think I broke my finger.

 OP: I can't believe you did that.

 Panel 3: Swing around to show Marilyn looking over at Kacey from the ladies room door.

 Marilyn: Do you want me to call the nurse?

 Panel 4: Kacey swings around. She is angry, almost screaming.

 Kacey: Oh, right! Just what I need! Don't you know? That's David's mother! What am I going to say to her?

Full script eliminates guesswork
As you can see, working from a full script has some real advantages: You know exactly where everything is supposed to go right from the start. It takes a lot of careful planning to work in full-script style, but if you like to have precise deadlines for your work, this may be the way to go.

The NOTES BECOME FULL SCRIPT

A full script reads a lot like the script for a movie or a play. To practice making a comics page, you'll work from a portion of a script.

While most Japanese manga artists do not work full-script style, many American manga and comics artists do. Requirements vary from publisher to publisher, so it's a good idea to learn each publisher's submission guidelines. Moreover, if you're an artist, there's a good chance you'll collaborate with a writer someday who will work in full-script format.

Here are pages 11 and 12 of our teen drama. You'll refer to this later on when you begin to create pages.

Words written in bold will be lettered with more emphasis.

(When lines of dialogue are separated, usually means the writer wants two word balloons for the dialogue instead of one.)

(SE means Sound Effect)

Page 11

Panel 1: Wide shot. School Hallway. Audra has just turned the corner to see the source of the sound. A girl is beating and kicking one of the lockers in the hall. The hall is empty except for Kacey and Audra.

SE: BAM! BAM! BAM!

Panel 2: Medium shot as we focus on the girl in the hallway, who turns out to be Kacey. She has not seen Audra at all and is wildly kicking at the locker.

SE: Bam! Bam! Bam!

Panel 3: Medium close on a shocked Audra.

Audra: **KACEY!**
WHAT ARE YOU DOING?

Panel 4: Silent. Same angle. Kacey has stopped beating the locker and is leaning against it, frozen.

Panel 5: Silent. Move in for medium shot. Kacey is leaning against the locker, hanging her head in despair.

PAGE 12

Panel 1: Close-up on Kacey whose head has whipped around as if, for the first time, realizing Audra is there. Her eyes are full of tears and they drop from her face as she turns. She looks devastated. Silent.

Panel 2: Close-up on Audra who leans back just a little, her eyes wide.

Audra: Gasp!

Panel 3: Extreme close-up of Kacey's weeping eyes.

Kacey: I know he's lying.

Settings

Time, place and set dressings will have a large impact on your story and characters. You'll need to think about these things as you develop your script (and again as you begin to draw your panels). Creating consistent settings will add believability to your graphic novel.

Try these exercises as you develop your script and panels.

Create concept drawings

Create concept drawings of important locations you will use repeatedly. You can also create a photo of exterior and interior settings shot from various angles.

Make line-of-action drawings

For complex scenes with many characters and/or important sets that will be shown again and again, it's helpful to sketch quick line-of-action drawings that track your characters' movements and show where they are standing in relation to important props. Some artists go so far as to create small-scale models of entire sets. Gerhard, the amazing background artist on the independent graphic novel series, Cerebus, created architectural paper models so he could accurately draw buildings and sets from multiple angles. Doll furniture can also help.

Get to know the floor plans

Make plans of the interiors of your buildings. It's easy to make mistakes without them. Say you have two bedrooms next to each other, and draw them consistently throughout an entire story. But then you forget the rooms are next to each other, and in the next story put a closet between them. Readers will notice. A floor plan will help prevent this.

Tips for DESIGNING CHARACTER

As a cartoonist, you will have to be able to draw any type of character and costume at a moment's notice and be able to adapt to all kinds of storytelling situations.

Designing a new character is perhaps one of the most entertaining aspects of creating a new story. But there are a lot of important points to keep in mind.

Practice drawing all kinds of people—short people, fat people, old people, young people. Your story will be far more interesting if it's populated by a variety of characters. Even if you're creating a story that features glamorous leading characters, remember to add other kinds of people to your supporting cast.

KEEP YOUR COSTUMES IN CHECK

In manga, character facial designs are often similar, so costumes are used to differentiate characters. Here are some basic rules to remember as you design your costumes:

Tone sheets can help define hair and features
To create highlights, cut away parts of a tone sheet using a craft knife, or rub out areas of the tone sheet with a sand eraser.

▶ Form follows function. Even in fantastical costumes, people should be able to wear them and walk in them.

▶ Reserve complicated costumes for short scenes and use the easier costume designs for long scenes. (Why? Consider that a graphic novel has 120 pages. If you design a complicated costume, and your graphic novel has an average of five panels per page, and your main character appears on half of those panels, then you'll be drawing that character three hundred times in one book. If your complicated costume has a fiddly bit that takes an extra fifteen minutes to draw per panel, you'll spend a whopping seventy-five hours of your life drawing that fiddly bit in only one book.)

▶ Costumes should be easy to recognize on sight.

▶ Don't forget hairstyles! Give your main cast of characters distinct hairstyles so you can readily tell one person from another.

▶ Buy hairstyle and trendy teen magazines a few times a year. Use them for one year, then throw them out.

▶ If you live in a city, get as many prêt-a-porter fashion magazines as you can. High-fashion magazines with runway photos feature clothing that trends a couple of years ahead of street fashion, so your designs will always be fresh.

▶ Keep files of clothing and fashion designs for each decade going back to the 1940s in case you need to draw stories that take place in recent history. Additionally, keep files for clothing styles from different centuries and regions of the world. Pay close attention to detail: Nothing will betray your designs faster than the wrong shoes, hat or other little mistake. While the majority of your audience may not notice, someone always will!

HAVE A PARTNER?

If you're working with a writer, read his or her instructions carefully and discuss them. Share photos and keep reference files of people, clothes and colors that fit your characters. Make sure you both know what you want for the story before you proceed. You don't want to have to go back and make changes after you have put a lot of work into your book.

LOOK AT REAL PEOPLE

It's tempting to spend all your time looking at comics for ideas, but your best ideas come from real life. Top manga and comics artists pay attention to the real world.

Observe the little quirks of movement that individuals display. Pay attention to babies, older adults and teens. Notice how they have different ways of moving and communicating. Body language is the most important tool for a cartoonist, so try to learn how people communicate without saying a word. Design your cast of main characters so that they can be easily recognized simply by the way they move or appear in silhouette.

Simple costumes can be striking
Tone sheets give this male fantasy character distinction—an easy way to achieve great results!

The leopard-print boots and textured jacket give character to this costume.

53

Make a model sheet

A model sheet is a representation of your ideal character look drawn on one page.
Each character gets his or her own model sheet, which shows the costumes and body
designs from different angles. This sheet enables you to get the details correct and
have a handy reference every time you sit down to draw.

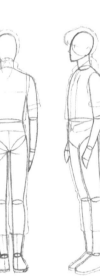

1 *Create a mannequin model sheet. Draw the mannequin figure from different angles. Show the waist, elbows, knees and other points falling in the same place in relation to how the body is turned. Turn down the tops of the feet in the first shot so you can see the shoe details.*

Make copies of this mannequin drawing and use them over and over. You can place it on a lightbox and draw directly on top to give you a quick model for your costume sketches.

2 *Draw the costume, ensuring that all the details fall in the same place on the body no matter how the body is turned. Use a ruler to make sure pockets, belts and other details always line up. You don't have to be perfect, but it's easy to get confused when drawing a costume from different angles.*

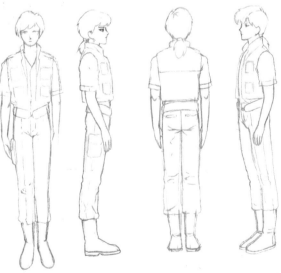
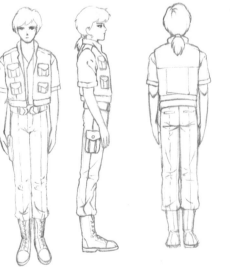

3 *Draw more costume detail, comparing the relationships of the costume parts in all the drawings on your model sheet. Begin erasing the underlying figure outlines. Make as many changes or corrections as you like at this stage.*

4 *Tighten up your pencil drawing. How do the details relate to each other? Are all the pockets in the right places? Did you double-check the part on the hair? If it is on the left side in one shot, is it on the left side in every shot?*

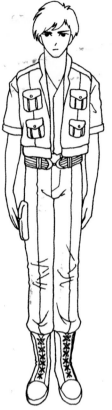

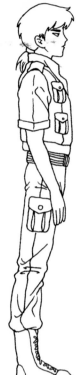

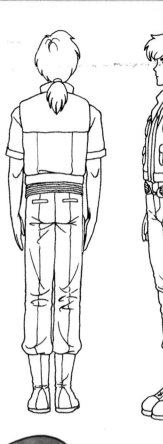

5 Finish off using ink. This will be your master model sheet for this character. Every time you draw him, you'll be able to get him just right. Double-check: Are the laces on his boots correct in every shot? Does his belt detail match?

6 Now, make a color master model sheet. I used felt-tip markers. Create letters and numbers to correspond to the specific marker colors. This way, every time you color this character, you know exactly which markers to choose. If you color with other tools, such as by computer or with paint, you can do the same thing. Naturally, if you're painting an entire comic, colors will vary, but for every character design, you should create a standard color master model sheet.

TRY IT!

Make photocopies of your drawing and color it in different ways. How does this affect your idea of your character? Keep a notebook or scrapbook. Cut out pictures from magazines that remind you of your character's color and design scheme.

PAGE CREATION

You've drawn faces and figures and plotted some stories. Now, the time has come to ask yourself: Why? Do I want to draw just for pleasure, or do I want to be published? Where do I want to be published? Will I publish a graphic novel, or serialize my story in comics format? How long will my tale be? Will I publish on the Web? With a big company? A small company? What about self-publishing? And why do I have to ask myself all of these questions now?

The answer to the last question is that the format in which you want to publish will have a great impact on your art and how you create it.

We'll use standard sizes and shapes for drawing comic art in this section, but feel free to make style and size adjustments accordingly.

Keep in mind that the size, publishing format and style of the art will have a great deal of effect on how many panels you put on a page, how much dialogue you will write, and how much detail you can add.

Art from **Warrior Nun Areala**, trademark of Antarctic Press

TECHNICAL SPECS

American-style graphic novels allow for original art that's large and heavily detailed. Manga demands smaller pieces. And Webcomic art needs to be drawn specifically to fit computer screens.

If your goal is to publish your original art, it's a good idea to get used to writing and drawing to publisher specifications, both for practice and for the day you submit a portfolio to a publisher.

Ultimately, whatever working method you choose that produces results is fine. But remember: Publishers have good reasons for requesting original art in a certain format at a certain size. You may have to make adjustments if you're going to be working with other people.

KEEPING IT SMALL

Manga art is usually created at a smaller size than American comics art. There are a number of reasons for this:

► The smaller the original art you create, the faster it is to draw. Mangaka must produce a lot of art every month to meet deadlines. Working at a smaller size helps the mangaka produce work quickly.

► Most manga art is created using tone sheets, and most of those sheets conform to the small original art size commonly used by mangaka. If your work is larger than the normal mangaka, you may not be able to find tone sheets to fit your work.

► Tone sheets are actually black line images broken up by a series of tiny dots. The dots are so small they appear as gray tones to the eye. They're easy to print and were used to create gray areas in comics long before computers. Since American companies no longer make tone sheets, most artists get them from Japan, where they're made to fit smaller art. If a tone sheet created for art that's about 7" × 10" (18cm × 25cm) is used on art that's 16" × 20" (41cm × 51cm), when the art is reduced to printed size, the dots get crunched together until they are so small and close, you don't have a gray tone, you have a black blob.

► Even art you create by hand will be printed using computers, and if your art is very large, it's more difficult for publishers to photograph or scan. Many publishers prefer

On large, American-style art paper, if the art is shrunk down to manga printing size, it can be very hard to see.

ART FROM **A DISTANT SOIL** © AND COLLEEN DORAN 2007

This panel uses a standard tone sheet used for manga-style art.

that artists turn in work that has been scanned and saved to disk. (You can hire a company to scan your art for reasonable prices.) Larger art is more difficult to scan than smaller art, and your art will be easier to handle if the image area of your original is no larger than the platen of an affordable scanner. You will save yourself (and your clients) a lot of money if you make your art size smaller.

DRAWING LARGER

American comics artists who work for major publishers usually use the assembly line system (page 11). Because of this, art tools and techniques in American comics became standardized to accommodate the work habits of the artists and necessities of printing the comics.

Imagine if every pencil artist turned in pages at different sizes. The letterer (who has to make sure the words are printed at the same size) would be forced to work much harder. The inker would have to change his tools and drawing technique to adjust to the changes as well.

Now that we've extolled the virtues of small art, you'll find there are also some advantages

to large art, the foremost being that when you draw a large picture, then shrink it down for publication, the art simply looks better. The lines look cleaner and sharper. For this reason, illustrators almost always create their original drawings to be larger than the printed sizes.

WHEN IT DOESN'T MATTER

If you write, draw, ink and color your own comics instead of using the assembly line system, it doesn't really matter how large or how small your art is created, as long as your originals are drawn proportionate to the final printed size. I now have permission from my editors at Marvel, Image and DC Comics to draw my original art much smaller than normal American style.

With the advent of computer lettering, it is easy for a computer letterer to adjust to match your drawing size. Many pencilers no longer work with inkers, choosing instead to ink on computer directly from the original pencil drawings.

WORKING FOR PUBLISHERS

American comics companies will want you to work on their company paper, which will save you from having to figure out how to measure things for yourself. Make sure your samples adhere to the standard specifications when showing publishers your work.

For American comics publishers, the outer edge of the paper measures 12" × 18¼" (30cm × 46cm). On the inside rim of that paper, two large rectangles are printed in nonphoto blue. The outer rectangle is called the *trim area*. Images that run off the page when printed are drawn to this edge. When an image runs off the edge of the paper, it's called a *bleed*. Never, ever draw word balloons or important art within this outer rectangle area—they may be left out of the picture when the book is printed.

The inner rectangle is called the *live area*. That is, all the important images and words go into this living space. The inner-rectangle live area measures 10" × 15" (25cm × 38cm). Some publishers use slight variations of this size, but the proportion usually remains the same.

So, if you'll be creating comics without a major publisher's input, or if you're considering self-publishing, do you have to work at this size?

No. But it is critical to always create your work using standard proportions. We'll explore this further in the next section.

PAGE PROPORTIONS

Comics printers and publishers in the U.S. usually print all books at the same size. If your book is the same size as everyone else's, it can be "gang" printed. That is, many different titles are printed at once, reducing printing costs. Changing the shape of your comic by even a few centimeters can greatly increase the cost of printing. Your publisher (even if your publisher is you) will appreciate it very much if it doesn't have to make special arrangements to print your comic at odd sizes!

No matter how large or small you choose to draw, you can always be sure of getting the right proportion with a simple tool called a *proportion scale*. The inner wheel represents the size of the original art. The outer wheel represents the reproduction size. The small window gives you the enlargement or reduction percentage.

Follow the steps on page 60 to prepare your page in proper proportion. The proportion scale will tell you at what percentage you need to enlarge or reduce the image for printing. If you want to include the outer-edge area for bleed art that will run off the page, simply repeat the steps with the outer lines of the comics page. Add about 1/8" (3mm) extra edge for trim on each edge.

To make a double-page spread, tape the back sides of two pieces of art paper together using acid-free tape. Or, if you're working with a small live-image area, you should be able to fit a double-page spread on a single piece of 16" × 20" (41cm × 51cm) paper.

Keep a master copy of your measurements page with the bleed area and live area clearly marked in dark marker. When it's time to draw a new page, you won't have to measure it. Just put

your master copy page on a lightbox, place a clean sheet on top, and voila! By tracing over the lines, you have perfect measurements every time.

Make a habit of keeping files of each publisher's regulations and art requirements. This will save you the trouble of asking the same questions over and over, or even save you from missing a deadline when you're working late and can't reach a client.

OEL COMPANY SPECS

OEL manga art proportions are different from those of American comics. Specifically, they are smaller and wider, and are printed to mimic the size and shape of manga as it is produced in Japan.

So, it's important that you don't use American comics proportions for OEL unless you're working for an American publisher that publishes OEL in the American comics size. Image Comics, for example, publishes OEL in both American comics format and OEL format.

For self-publishing, you can do whatever you like. But making unusual choices can greatly increase the cost of printing your work.

Finally, despite the fact that most publishers use standard sizes, you'll always have assignments where these size rules will be broken. You may need to do illustrations, comic strips or magazine work following different standards and specs than you're used to.

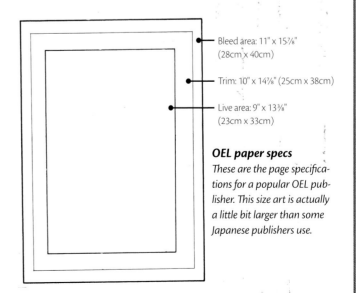

Proportion scale

Bleed area: 11" x 15⅞" (28cm x 40cm)

Trim: 10" x 14⅞" (25cm x 38cm)

Live area: 9" x 13⅜" (23cm x 33cm)

OEL paper specs
These are the page specifications for a popular OEL publisher. This size art is actually a little bit larger than some Japanese publishers use.

Enlarging your page with correct proportions

Why bother preparing your paper to spec when you can buy preprinted comics art paper? Well, preprinted comic-art paper is more expensive than simply buying your own paper and drawing lines on it. Also, there's no guarantee that you'll find paper in the size or weight that you need. Using the following method, you'll be able to make any paper work for you.

The inner rectangle is the live area of the printed comic art.

The outer rectangle is the edge of the comic book page.

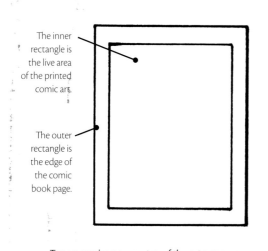

1 *Tape a comics page on top of the art paper you want to draw on.*

2 *Using a ruler or T-square, draw a straight line that extends diagonally across the bottom and top corners of the live area and onto a larger sheet of paper.*

3 *Draw another straight line across the bottom and side. Then connect the lines. You now have an original art page sized exactly to the proportions of the comics art page.*

LAYOUTS and SHOT SELECTION

No matter how complicated your story is or how detailed your drawings are, you have one task that trumps all others: You must tell the story in a clear, concise and readable way.

If readers have to puzzle over which word balloon comes next, where their eyes should go to see the next panel, or what's happening from panel to panel, you have a problem.

Your book will be seen by people who don't know you. They don't know what you're trying to say. They only understand what you put on the page. You must be able to speak in a visual language that they will understand.

American manga fans first became acquainted with Japanese versions of their favorite manga. They couldn't read a word of Japanese, but they could follow many aspects of the story just by looking at the pictures. Your storytelling technique should be clear enough that people who don't speak English will be able to immerse themselves in your work from the visuals alone.

There are several methods you can use to control the reader's eye. There are different layouts, such as simple, horizontal, vertical and montage. You can also make use of different shot selections to force the reader's eye to look at each frame in a certain way. Some examples of shot selections include:

▶ An ESTABLISHING SHOT, a panel that focuses on the location and establishes where and when
▶ A WIDE SHOT, a panel that focuses on an area, such as a city block or a room, establishing the location of a scene
▶ A MEDIUM SHOT, a panel that puts the figures waist high in the panel
▶ A MEDIUM CLOSE-UP SHOT, a panel that frames the head at the shoulder
▶ An OVERHEAD SHOT, a panel that moves your "camera" over the figures and shoots from above

As you create these shots, remember to use *negative space*, which is a common design motif in Asian art. Negative space can be either a large area of simple black space or a large area of empty white space. Negative space gives the eye a place to rest and keeps your reader engaged.

THE SIMPLE LAYOUT

The simplest and clearest layout is the grid, in which the eye starts in the upper left corner and zigzags across the page. Almost all American comics read in this way or some variation thereof, because the Western eye is trained to read from left to right and top to bottom. So most of your layout designs will be some variation of a large Z-shaped grid, no matter which way the panels rest.

A plain, simple layout won't be boring if interesting things happen within the panels. Moreover, sometimes a simple layout is best for the story.

The more complex the material being conveyed, and the more detailed the drawings, the simpler the layout should be. This framing device of the simple layout keeps the reader's eye focused on the information being conveyed instead of bouncing it around the page.

The simple layout

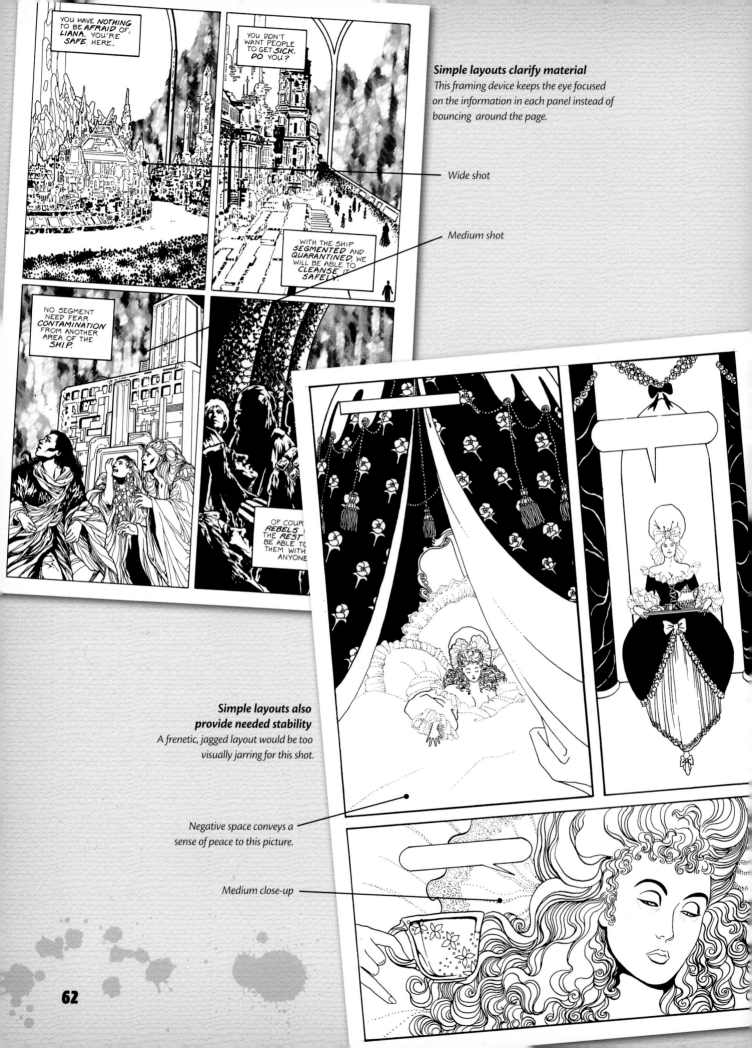

Simple layouts clarify material
This framing device keeps the eye focused on the information in each panel instead of bouncing around the page.

Wide shot

Medium shot

Simple layouts also provide needed stability
A frenetic, jagged layout would be too visually jarring for this shot.

Negative space conveys a sense of peace to this picture.

Medium close-up

Vertical Layout

A vertical layout can be simple and effective or just a big waste of space. It's important to design the page so that it takes advantage of the reach and scope of the vertical panel design. The panel design still gives readers a zigzag pattern to aid their reading order, but the big Z-shape may be tipped on its side.

Vertical layout

Overhead shot

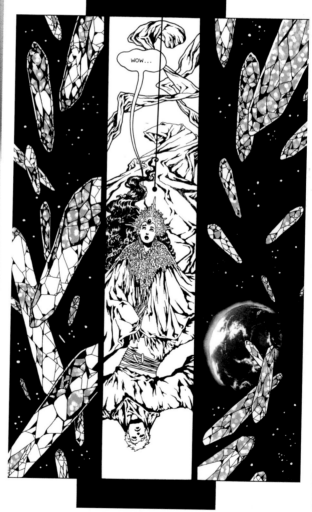

Use vertical layouts to convey story progression
In this scene, huge crystals from an alien spaceship break away and float off as the center shot gives the villainess a chance to gloat. The negative space at the top of the first and third panels lends the crystals enough visual "breathing room" to give the impression they're floating in free space. The tilted crystals in the last panel also point the reader to the next page.

Create rhythm and progress
Repeating the layout not only creates a sense of visual rhythm, but also gives the impression of slow-motion progress. Again, the crystals point the reader to the next panel and to the next page.

The Horizontal Layout

The eye bounces back and forth in the horizontal layout. Your eye may rest for a bit, it may swoop across the page, but the layout forces your eye to follow the narrative in proper sequence.

Horizontal layout

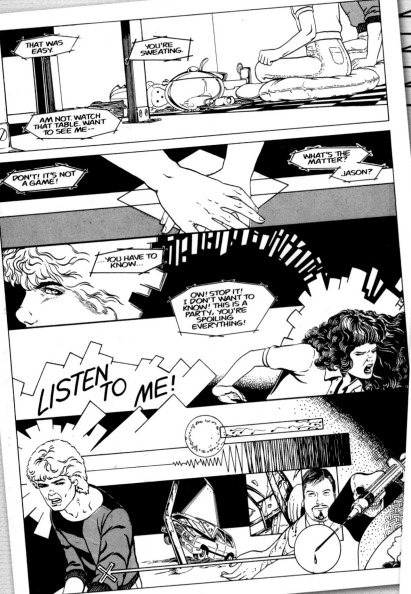

Horizontal layouts force the eyes to snap back and forth
In the first panel, the focus is on the table, then moves to the people sitting on the other side of the room. Our eyes snap back and rest on the next panel, as the clasped hands sit in a frame and make our eyes pause. Then the motions depicting the telepathic powers between the boy and girl snap our eyes back and forth across the page. This kinetic effect is best achieved with a horizontal layout.

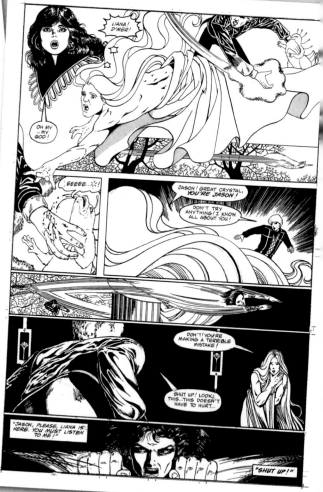

If the story calls for it, give your characters more room
On this page, the action sweeps back and forth. Think how cramped this scene would look if it were drawn in tight, vertical panels!

The Montage Layout

Montages are pages that combine a variety of shots and graphic themes to create a splashy visual effect.

TRY IT!

▶ Create ten different layout ideas that make use of the horizontal layout. Think of panoramic landscapes, fight scenes and other sweeping motions.
▶ Soaring vertical panels are great for action shots, like flying. Sketch ten different scene ideas for which you would use vertical panels.

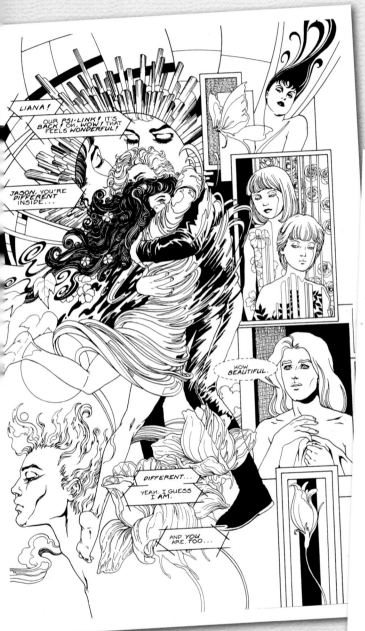

Don't overuse the montage
This page is full of symbols and emotional content, but if every page were drawn like this, it wouldn't be a special moment. Be careful not to overuse montages, splash pages (full-page drawings), and double-page spreads. They look pretty, but if everything is special, nothing is special. Follow the example of manga master, Osamu Tezuka, and save big graphic moments for very important storytelling points.

Use montage moments to incorporate elements from art styles
Much of the inking in my work is influenced by the art of Aubrey Beardsley, a nineteenth-century English illustrator who was influenced by Japanese art. (He also influenced several well-known manga artists.) This page uses visual themes from Beardsley's work.

A couple rules for VISUAL STORYTELLING

Follow these guidelines as you choose shots for your panels and decide where to guide the viewers' eyes. By learning these rules, you'll become a better cartoonist and will better understand film storytelling. You'll also be well on your way to being able to create film storyboards (many cartoonists also work as storyboard artists):

1 The character on the left speaks first.
2 Viewpoint must remain along the 180-degree line and line of action.
3 The "left speaks first" rule trumps the "180-degree" rule.

180-DEGREE RULE

Imagine two figures standing facing each other. A blue line separates them, and a half circle (180 degrees) creates an arc on one side of a red line. The red line is the line of action; the red arc is the 180-degree line.

You may *not* shoot the scene on the other side of that arc. And do *not* let our eyes cross that blue line *unless* you show the character moving across the line of action.

Viewpoint must remain along the 180-degree line (the red arc)
The eyes represent a few possible camera viewpoints. You can shoot the scene from any spot along the 180-degree line.

HOW THE 180-DEGREE RULE WORKS

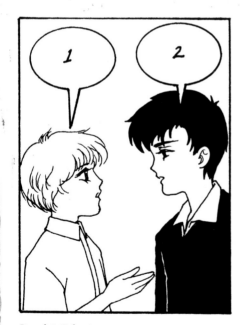

Panel 1, Take 1
Our blond boy, Gerald, and our dark-haired boy, Fred, converse.

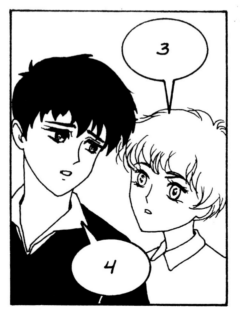

Panel 2, What just happened here?
It looks like Fred switched places with Gerald. He crossed the invisible blue line down the middle and the line of action. Our image flopped.
 Let's try this scene another way.

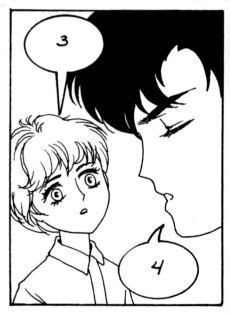

Panel 2, Take 2
Much better! Both figures remain on the correct side of the invisible blue line and in their places on the line of action.

You *can* allow our eyes to cross the blue line if you actually show the character moving along the line of action to do it.

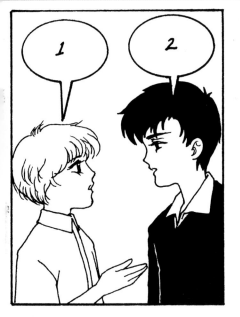

Panel 1, Take 3

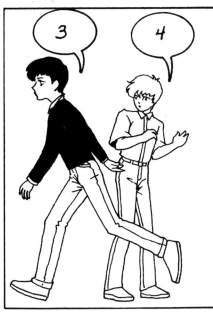

Panel 2, Take 3

Fred doesn't just suddenly appear on the opposite side of the panel; we see him moving along the line of action and walking over there. This makes more visual sense than showing him mysteriously transplanted.

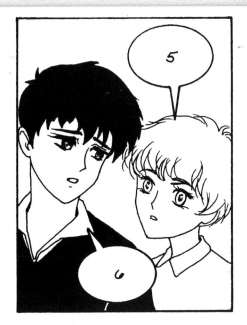

Panel 3, Take 3

Gerald and Fred are free to carry on the scene without breaking the "180-degree" rule.

But wait! Now we're breaking the "left speaks first" rule! If the speaker on the right MUST speak first (and in comics, since the pictures aren't moving, sometimes this happens), make sure the word balloon of the speaker on the right is placed higher in the panel than the word balloon of the speaker on the left. The reader's eye will naturally go for the higher word balloon first and read the balloons in the correct order.

Panel 1, Take 4

It's important to pay attention to word order, character position and word balloon placement. Otherwise, you end up with shots like this. How confusing!

Panel 1, Take 5

Angling the camera up a bit, you can move the word balloons around until they fit and still follow the rules.

67

Drawing a manga page

Many how-to books show almost perfect pages drawn in only three or four steps. I used to get intimidated looking at these, as it looked like the artists who created them never made any mistakes. That's not very realistic.

In this segment, we'll practice drawing pages in the manga style the real way, with all the mistakes and doodles. Your comics don't have to be perfect at every stage. You can change your mind as you go, smear something, skip sections and come back later. The only thing that matters is the end result.

Also, while you've learned to use blue pencil for some demos so far, for these exercises I used regular pencil because it is a little darker and easier to see. If you want to keep using a non-photo blue pencil for your early sketches, that's OK.

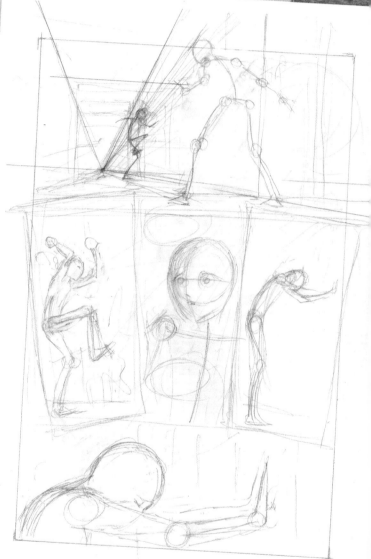

1 *Using the page 11 script (page 50), make a thumbnail sketch. (Layout paper is a good choice for these sketches because it has small ready-made blocks and room for notes. Sometimes thumbnail sketches can be so loose that it's hard to remember what you doodled later! If you think you might not understand your own doodles, add notes to them.)*

2 *Using your thumbnail as a guide, make a larger layout. You don't have to be tidy or follow every part of your thumbnail. The layout is simply groundwork for your drawing.*
Sketch in basic stick figures. These tell you how your characters are moving, but can be easily changed later. Also, sketch in the basic plan for the hallway shot in Panel 1. Arrange the figures loosely by sketching in rough perspective line ideas.

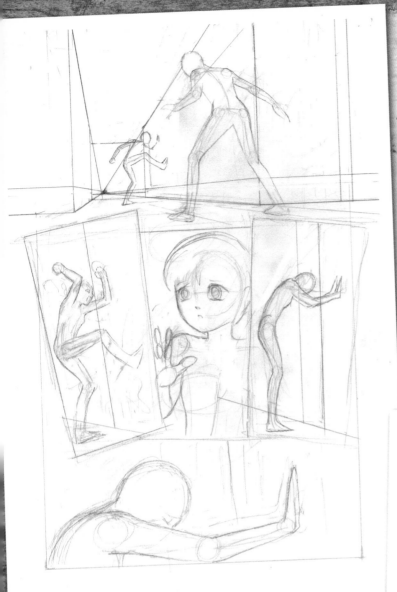

3 Begin Panel 1, using one-point perspective to show the depth of the hallway. Before you continue drawing the figures, draw the horizon line straight across the bottom corner of Panel 1 and add the vanishing point. Erase the sketched vanishing point lines and draw the perspective lines correctly. Make sure the figures line up and are in proportion to the height of the hallway walls.

Sketch in a bit more of the figures' forms. Keep the sketches loose. There's always time to make changes, and loose sketches are easier to correct.

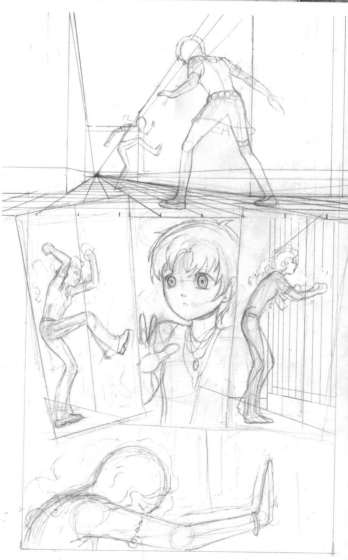

4 Make sure the tiles on the hallway floor in Panel 1 are drawn with the correct perspective. See the small dots at the edge of the panel? They are each exactly 1-inch (3cm) apart. If you want to add more tiles, make the spaces between them larger. For fewer tiles, make the spaces smaller. Then, draw a series of straight lines horizontally across the floor, making sure the tiles are lined up diagonally with each other.

In Panel 4, change Kacey's pose to make it more interesting.

Using an Ames Lettering Guide, draw the guidelines
for the word balloon copy in pencil.

Draw the special-effects lettering as short, hard
lines. Also, draw the edges of Panel 2 in scratchy strokes to give
the whole picture an angry feeling. To give your lettering more
emphasis in Panel 3, use a heavier pen point and draw your
letters so they slip slightly outside the lettering guidelines.

Use a template to create perfect ovals for the balloons.
Simply place a plastic oval template on your art and trace the
interior with a pen, leaving a small hole in the balloon for the
pointer. Use a ruler or the template edge as a straightedge for
ruling the clean lines of the pointer.

Use a vanishing point to help you draw Panels 2, 4, and 5.
The lockers appear in these panels and will need to be drawn in
perspective.

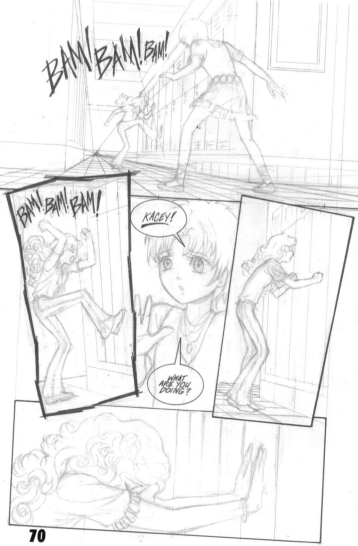

Erase your figure drawing guidelines. This is often the best
part of drawing a comics page because before this point,
the sketches can look chaotic, and then suddenly the pic-
ture starts to make sense! Clean up the outer edges of your figures and
begin fleshing out the details.

If you're right-handed, don't use heavy black ink on the right side of the picture unless you have time to let it dry. Right-handed artists should start on the left, and left-handed artists should start on the right.

Ideally, you should be drawing several pictures at a time, so you can move back and forth between them. This will prevent you from becoming bored and will give your ink time to dry.

7 Using speed lines (lines used to represent motion or speed) when no one is moving is a great way to convey shock or tension. In Panel 1, quickly sketch in some lines toward the center of the page. Continue to round out the figures with smooth lines. You can work as tightly or as loosely on the pencil art as you like, but since you'll be inking this for yourself, you may want to skip some details and save them for the inking stage.

8 It's sometimes best to start inking a page like this by concentrating on the major figures. For this demonstration, try inking with a pen. In this case, I used a Deleter marker with a .3 point. The delicate lines work well for manga.

9 Many artists don't draw speed lines such as in Panel 1 by hand, but use tone sheets. However, sometimes the exact lines you want aren't available. Doing them by hand takes time but gets you exactly what you want. Just direct your ruler at the vanishing point as you did when drawing the floor. Then draw tiny lines, some close together, some far apart, all around the panel.

Now is also a good time to add small areas of solid black to the page. This helps balance the black and white areas.

10 You are very nearly finished. Draw the lines of the locks and air vents on the lockers so they all lead to the vanishing point. You don't have to finish every detail of the lockers, wall or hall. This can actually distract your reader from the action. And remember: Manga are often printed very small. If you use too much detail, it will look muddy when printed.

11 Use a tone sheet for Kacey's shirt or leave it blank. This paisley print might be too small for a manga, and the details will make the lines and ruffles on her shirt disappear. Always keep in mind how your art will appear when printed.

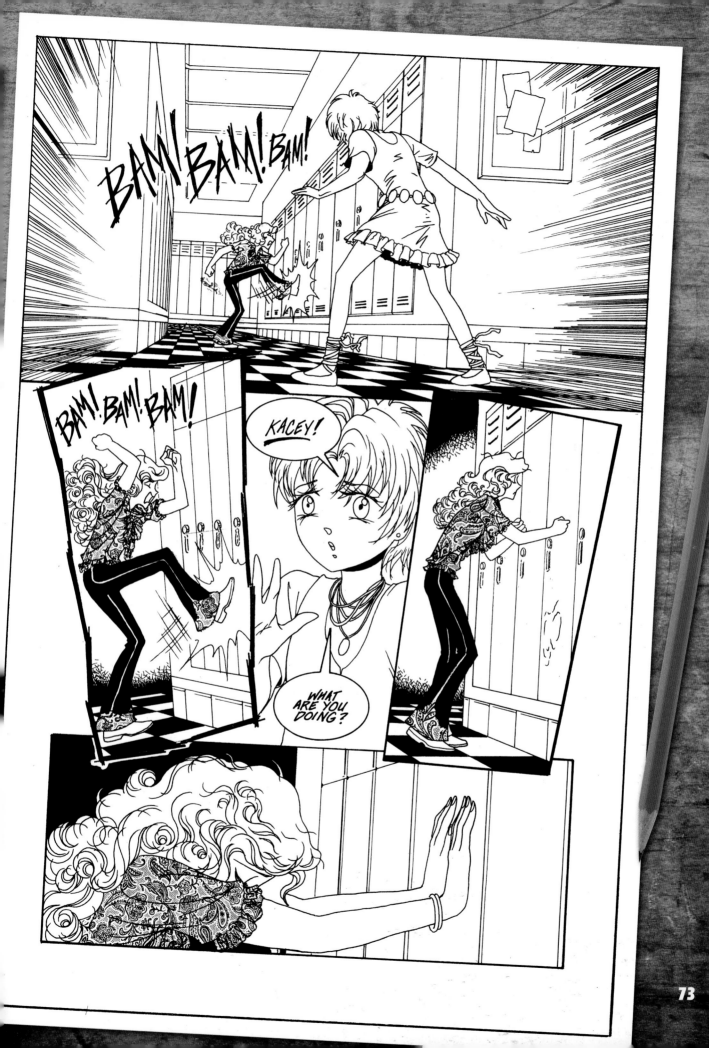

Creating pages of strong emotion

Now we are going to draw a page that focuses entirely on expressing emotion: page 12 (page 50).

Being able to draw convincing moments like this will make your art stand out. Many wonderful artists can draw handsome buildings and convincing figures, but their art is cold and heartless. Readers should feel every moment of your story.

1 *Even though you're working from a full script, it's good to create a shitagaki like this as well. You already have your dialogue and action written out in advance, but creating a shitagaki enables you to place your word balloons while you produce your thumbnails. Also, it is a good idea to submit this kind of preliminary work to an editor. At a glance, she can see the rough sketch as well as the words, without having to refer back to the original manuscript.*

2 *Make a quick layout of your page idea. Even though part of the head will be cut off by the edge of the panel, sketch in the entire head shape. Otherwise, you risk placing features incorrectly or flattening the head. Just loosely doodle in the features. Don't use detail.*

3 *Refine the shapes. Using guidelines, make sure that the facial features fit correctly in the head. Draw the lines so they flow around the head, following its shape. Facial features should appear smaller as they recede from the reader's view.*

Rough in the shape of the hair, and give the eyes some attention. This scene should be heart wrenching, so make the eyes large, liquid pools for your readers to fall into.

4 The earlier you add lettering the earlier you can see how it fits with your composition. And you don't have to draw art that appears underneath lettering.

In this case, it's a good idea to leave Panel 3 as open as possible for those big, sad eyes. A word balloon might spoil the shot. Add the lettering in Panel 2, but point it to Kacey in Panel 3. This way the dialogue fits and *works with the art.*

5 Give Kacey and Audra distinct hairstyles. Make Audra's hair a series of interlocking, short, spiky strokes, and draw Kacey's hair as a mass of S-curves and waves.

Add those big manga eyelashes and pupils.

6 Refine the drawing and erase guidelines. It is very easy to make big eyes like this slightly cross-eyed, so double-check your drawing: Look at it upside down and backward in a mirror. Is the jaw too wide? Are the eyes set too closely together? Too far apart? Before you start inking, make sure you haven't made any mistakes that will be hard to fix.

Let the drawing sit overnight. Then look at it with fresh eyes in the morning. If you can, let it sit for a week or longer, then look at it again. Has your opinion changed? Can you see mistakes?

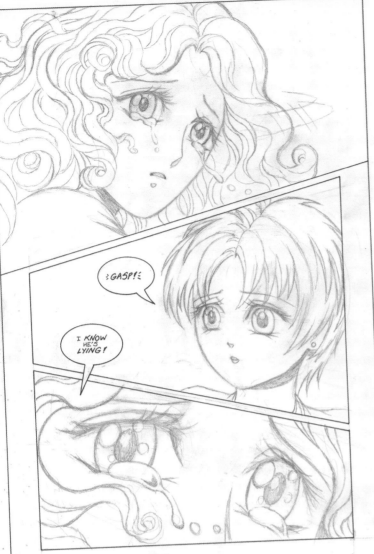

A crow quill pen drips easily because it's basically just a little metal point with a hole in it that you dip into an inkwell. Before you put that pen onto your art, tap the point against your bottle of ink. If the ink is about to drip, it will drop into the bottle instead of all over the page.

 Complete the final drawing details. Most manga artists don't have the time to produce a pencil drawing this tight, which is why this technique is usually only used by Western artists working with the assembly line method. Experiment with tight pencils and loose pencils before you ink to find out what works best for you. Draw little speed lines to indicate Kacey's head whipping around in Panel 1. Clean up all your lines and erase any stray sketches. Add some shadows to the tears to give them shine.

Use a crow quill pen or a brush to ink the major shapes, such as Audra's and Kacey's hair. This will allow you to draw flowing curves of varying thickness. Did you like using the Deleter marker in the previous exercise, or do you prefer this technique?

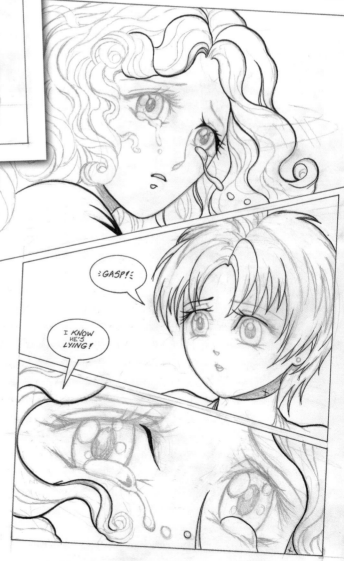

9 Get ready to ink the hair. Practice drawing curves on a separate piece of paper until you feel comfortable. Lots of artists "warm up" their hand every morning by drawing lines on scrap paper.

There is no secret formula to drawing beautiful flowing hair. It just takes practice to develop a steady hand that can draw smooth lines.

Speech bubbles (left page):
;GASP!;
I KNOW HE'S LYING!

MECHANICAL PENS WITH TEMPLATES?

Some artists use mechanical pens with curved plastic templates to keep their lines smooth and even. I don't recommend it. The final result is often lifeless.

Speech bubbles (right page):
;GASP!;
I KNOW HE'S LYING!

10 Add big, lustrous black spots to the eyes to give them depth. Be lavish with the eyelashes—this is manga, after all! Add shadows under the chins to make the heads look more three-dimensional.

Make sure the highlights in the eyes of both characters show light that's coming from the same direction. Kacey and Audra are in the same hallway facing one another. The light is shining on Kacey from above right, so the biggest highlight on her eye should be on the right side of her eyeball. (Likewise, if it is on Kacey's right, it should be on Audra's left.)

It's OK to play a bit with lighting and perspective to create a more attractive picture. Obviously, no one has as many highlights in their eyes as Kacey and Audra do in this scene. But follow the basic rules of drawing.

11 Add a cloth-pattern tone to Kacey's shirt. Use a foggy tone in the background of Panel 1 to suggest Kacey's lost and sad look.
In Panel 2, add an electrifying, shocked tone sheet to symbolize Audra's disbelief.

Decompressing a Western comic page

Take a Western-style comic page told in a compressed way, and turn it into a decompressed manga page. This will give you some direct practice and experience with different storytelling styles. You might even want to try turning some manga pages into Western-style comics pages sometime. See page 8 for a refresher on the differences between compressed and decompressed storytelling.

Because it has a spaceship and guns, the technical drawing of this page may be a bit tricky, so spend some extra time on your penciling. But even though the finished results may look hard, everything on this page is actually quite easy to draw. This will be a montage-type page with five figures on it, so you will get a good chance to practice your drawing. Use a tight pencil drawing to prepare it, as if it was going to an inker.

1 *Make a shitagaki. Since you already know the scene and dialogue, concentrate on redrawing the first couple of panels. Make a rough layout using stick figures and shapes to block in your ideas.*

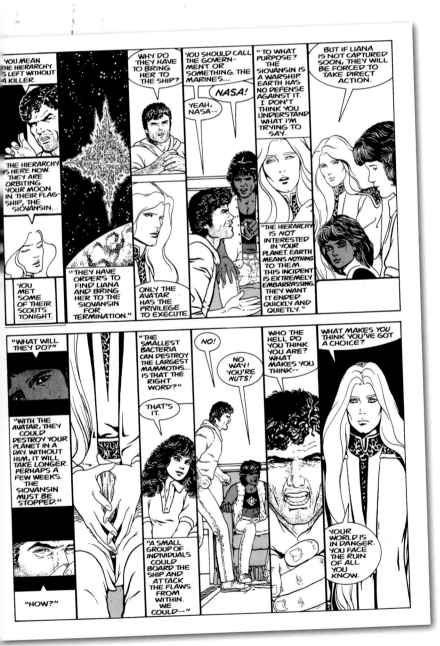

You've been adding lettering later in the drawing process on other pages, but try it now and see how you like it.

Start Here
Here is the page from A Distant Soil from page 8.

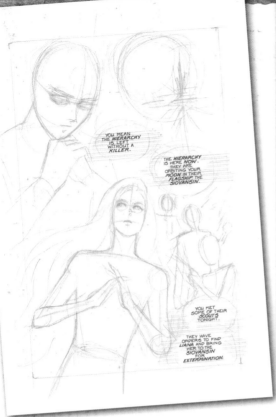

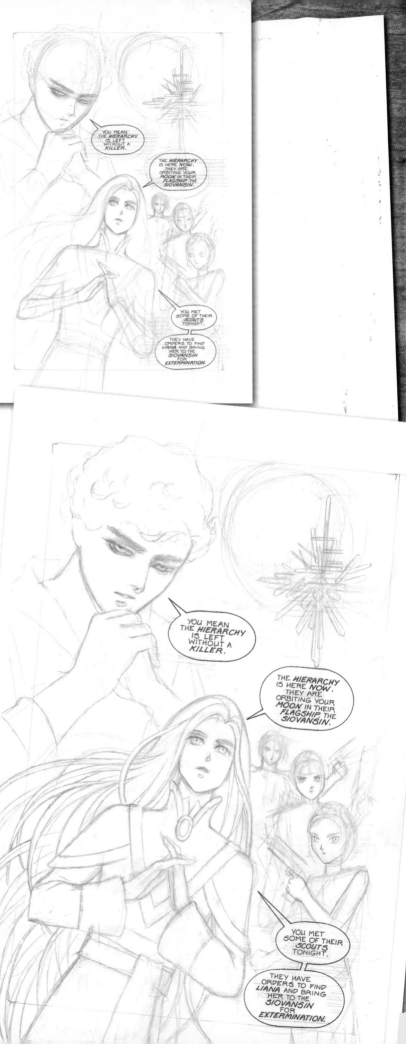

 Carefully round out the figures, paying attention to shapes.

 Start blocking in the costumes of the major figures, as well as features and hair, while refining the background figures.

 The picture will start to come together as you refine the costumes and hair. The long hair of the main figure is just a series of interlocking, slightly curved lines. Adding these details isn't difficult, just time consuming.

DON'T FORGET THE LIGHTBOX

If you don't like to rework your rough sketches to get to your final, clean drawing, remember that you can always place your rough sketch on a lightbox, and do your final, tight drawing on top of the rough. Sometimes all those loose lines can be confusing; sometimes they can be liberating, giving you design ideas.

Reference photos

These photos are from my files—crystals/rock formations (for the crystal formation on the ship) and a man's hand holding a gun (since our soldiers are holding guns).

You don't have to copy reference photos—just use them to enhance your ideas and to give you another way to study objects.

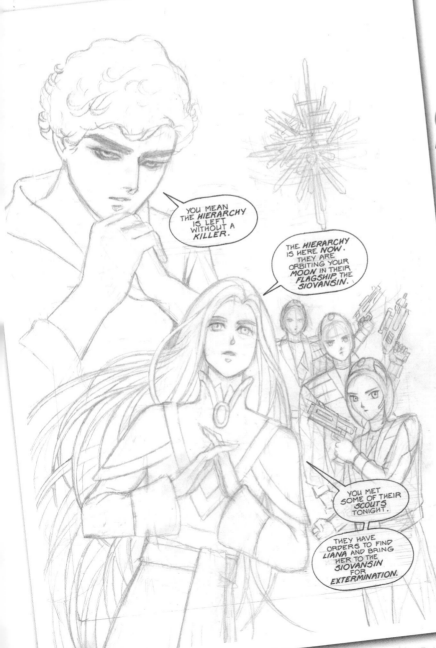

YOU MEAN THE *HIERARCHY* IS LEFT WITHOUT A *KILLER*.

THE *HIERARCHY* IS HERE *NOW*. THEY ARE ORBITING YOUR *MOON* IN THEIR FLAGSHIP, THE *SIOVANSIN*.

YOU MET SOME OF THEIR *SCOUTS* TONIGHT.

THEY HAVE ORDERS TO FIND *LIANA* AND BRING HER TO THE *SIOVANSIN* FOR *EXTERMINATION*.

6 Draw the crystal spaceship as a series of criss-crossing lines, then add the props and continue tightening. Your drawing is nearing completion, but because it's a bit complicated, you'll want to make sure it's clean and tight before you hand it over to an inker. Guns are easy to draw when they're flat, so there are no perspective problems to worry about here.

TRY IT!

Create your own reference files. Clip out potentially useful pictures from discarded magazines and file the pictures. Do this at least once a week. Promise yourself that you'll also take photos every week for your reference files.

81

 Use X-marks to say "this is a big black spot." (You don't want to spend the day drawing in black areas.) Spend as much time refining the drawing as you can. Clean up the stray lines and check the art upside down and in the mirror. In this drawing, I noticed that one shoulder was a little heavier than the other, one eye a little lower.

Start by inking in the lines around the major figures to help you visualize how the final picture will look. For this portion, I used a crow quill pen.

A large area of black hair can be tricky to draw. All those sweeping black lines take a while to draw and a lot of time to dry. It is easy to smear the ink! Use a permanent felt-tip marker and a ruler on the crystals of the spaceship and on the guns.

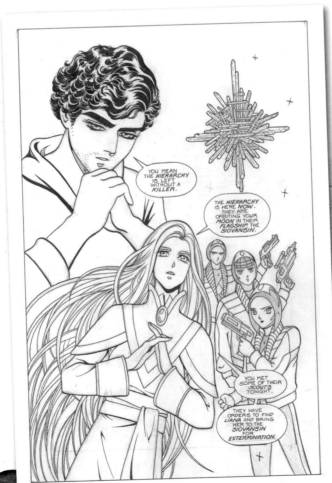

INKING WITH TEMPLATES OR RULERS

If you use a ruler or template while inking, make sure that the ink does not touch the edge. The ink may sink under the lip of the ruler and smear.

Turn the ruler over and use the side of the straight edge that sits off the surface of the paper. Affix pieces of masking tape or little adhesive felt dots to the bottom of the template to achieve the same effect. This will raise the template off your paper, allowing you to rule lines and curves without worrying about ink slipping under the edge.

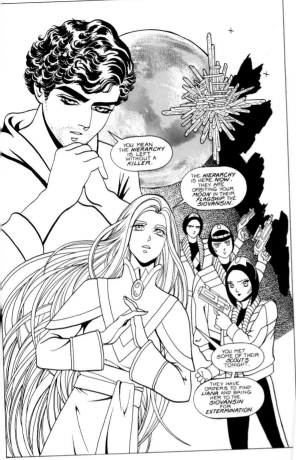

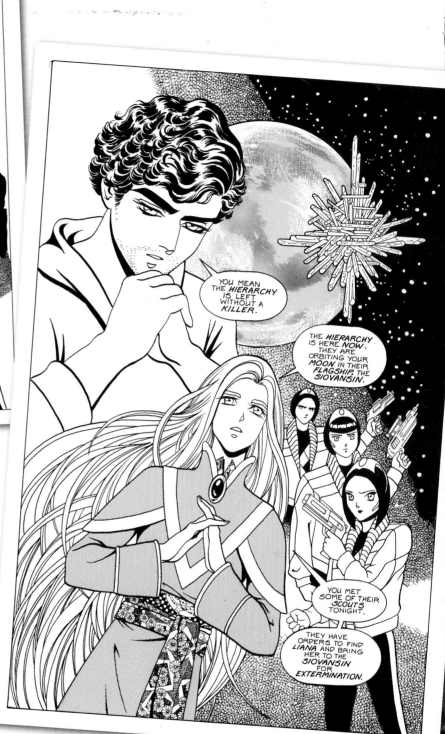

10 This is one of the few instances when you can use tone sheets before the rest of the inking is finished.

Use the moon from a tone sheet with preprinted planets. You can save yourself hours of work by using a hatching tone sheet as well. However, to finish off the piece properly, you'll have to do some extra drawing to make the hatching fit naturally into your picture.

11 Always save large areas of black for last to give them time to dry and prevent curling. (Even good paper can curl a bit when there is a lot of ink on it, and that will make it harder to ink the rest of the page.) Use white correction fluid to do the stars. Add costume details with more tone sheets. It's easy to mimic the hatching technique by hand, and by finishing it off yourself, it just looks better.

Making a battle page with no script, and no hits

Lots of characters have superpowers, but it can be fun and exciting to come up with ways to show tension and action that don't involve punching or kicking. This will also give you practice working with only a plot (see plot/Marvel Style on page 48).

In this scene, Kovar, a male guard, and Sere, an evil aristocrat, face off against each other, about to engage in a psychic battle. When Kovar threatens, Sere attacks.

Let's stick to a horizontal layout for this scene.

1 *As before, create a shitagaki with panel shapes and stick figures first. In Panel 1, Kovar and Sere will face each other. In Panel 2, we will show a medium close-up of Sere. In Panel 3, Sere will strike out. In Panel 4, Kovar will stagger backward.*

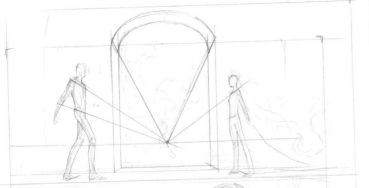

 Use one-point perspective in Panel 1 to create an open foyer that will lead to a garden. Kovar and Sere will face each other before a twisted tree.

Begin fleshing out your figures. Since the figures twist and turn, pay attention to the foreshortening of the bodies. Remember that the arm is like a cone: It will be wider as it gets closer to you, and thinner as it gets farther away.

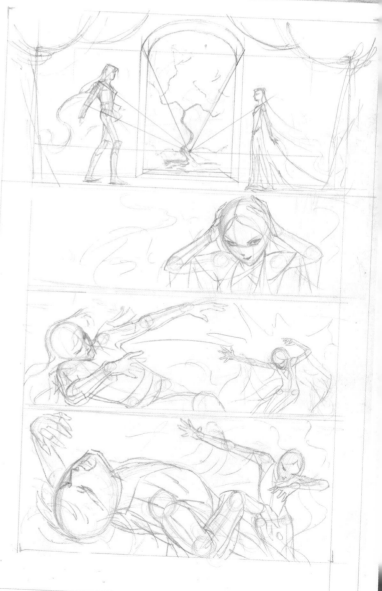

 Begin the costume details, drawing the hair and clothing so it flows around the shape of the body. Even though your drawing is flat, you're creating the illusion of roundness. The belt should wrap around the waist, and the cuff should wrap around the arm. Keep your drawing loose and easy at this stage. Be careful not to let your pencil cut into the paper.

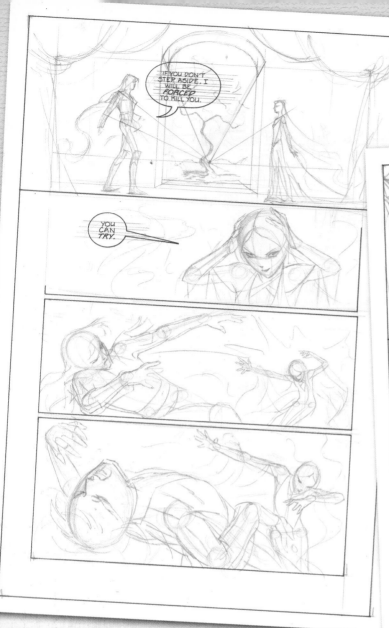

4. Add the lettering so that it causes the eye to flow along with the story. The word balloons echo the falling shape of Kovar. Notice how they seem to lead your eye right down the page with him.

5. Erase the guidelines and clean up the drawing. Suddenly it looks so much better! If you have trouble inking over so many sketchy pencil lines, just put your sketch on a lightbox, and draw on a clean piece of paper. Energetic triangle shapes will symbolize psychic power here. Since you are going to add tones to these shapes, you may want to keep them simple. It's hard to cut tones around tiny details.

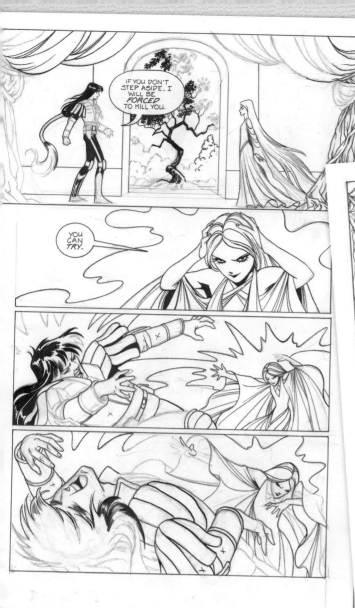

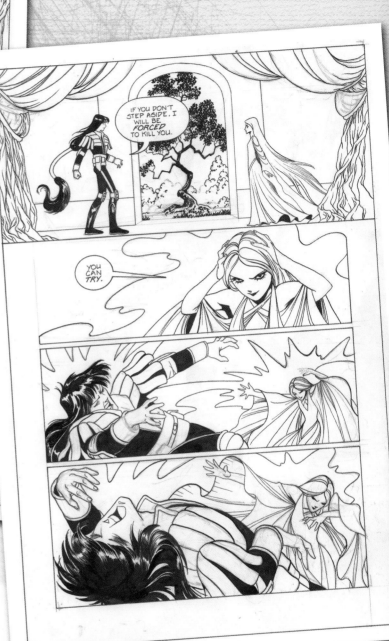

 Use a crow quill for this page.

This pencil drawing isn't as tight as others we've done, but it's good to practice inking over sketches. Indicate large areas of black that you don't want to begin just yet with an X-mark (for example, Kovar's hair in the last panel and the background). Complete these toward the end.

Small, smooth line details can be drawn with technical pens instead of a crow quill or brush. It's faster and easier.

TRY IT!

Come up with three different visual special effects for magical or other special powers that you've never seen used before.

7 To ink the tree, use a crow quill or brush, adding dabs of ink for the leaves. The black leaf clusters on the large tree will add depth to the picture, as they'll stand out against the fine line drawing of the rest of the background. Curtains look best when inked with a crow quill, but if you're using a mechanical pen, add some wavy lines to the folds so the material will look soft.

Kovar's hair can be inked with a brush or crow quill, but add fine lines with a felt-tip marker. Warning: The marker tip may be damaged by touching the residue from previously inked areas. India ink leaves a bit of texture on the paper, which can roughen up the fine point of a marker.

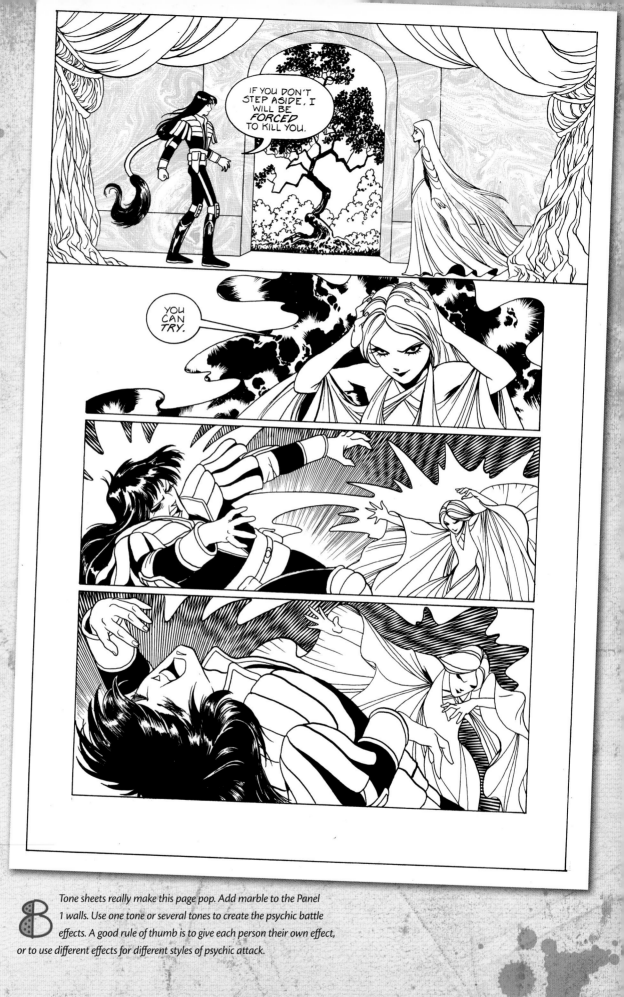

Tone sheets really make this page pop. Add marble to the Panel 1 walls. Use one tone or several tones to create the psychic battle effects. A good rule of thumb is to give each person their own effect, or to use different effects for different styles of psychic attack.

Think in ink

Many artists prefer to do a tight pencil drawing before they begin inking their work. Sometimes this is just fine, especially for Western comics artists who have more time to draw their books than Japanese manga artists. However, drawing a full page of pencils before beginning the inks is very time consuming. If you have the confidence to sketch out your ideas roughly in pencils and then to "think in ink" by finishing the sketch without doing a tight pencil drawing, you can save hours of effort per page.

Again, you are not going to work from a script. You'll draw from this short plot: D'mer, who is a pyrokinetic (he can generate fire with the power of his mind), will fight with another character who is attacking him with knives. D'mer must fight this man without killing him, which means he has to be careful when using his fire powers.

1 *Begin with a pencil sketch. Use a layout that is more Western in style and tone for a change, and give the page some power by using different panel shapes. Rough in the main figures as stick figures.*

 The key to drawing a fight scene is to give the figures energy. It's OK to exaggerate the length of the figures and their motions because this makes them seem more animated. Stretch and squash them for emphasis.

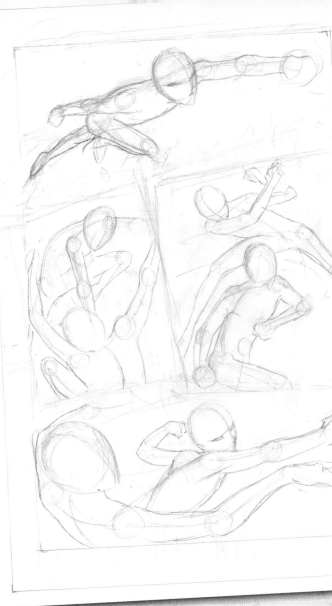

TRY IT!

Draw at least three panels using the "think in ink" technique. Practicing drawing directly in ink will give you more confidence, so just try it out.

 Free, fluid pencil lines will produce free, fluid figures. Don't worry about being perfect—just tell the story. Keep in mind how people actually move. When the left leg moves forward, the left arm moves back. When someone throws a punch, their body twists. Get up and dance around, and act out the scenes if you must. It's OK—no one is watching!

Add the clothing and hair sketches directly over the figure forms.

No matter how difficult it may seem to draw the human figure, remember that you always have a ready-made reference: a mirror. Keep a mirror near your drawing board and look at yourself as you strike a pose. This is especially helpful when you're drawing the hand and arm in foreshortened poses.

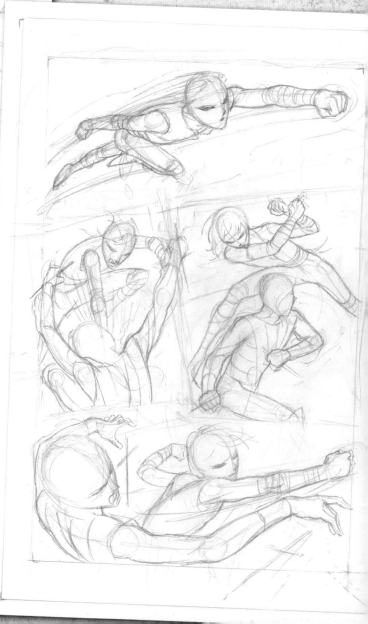

5 Add the lettering. You can use round balloons like this, or you may prefer to use pointed balloons that convey more emotion. Experiment with different balloon shapes on a piece of scrap paper before adding them to your original art.

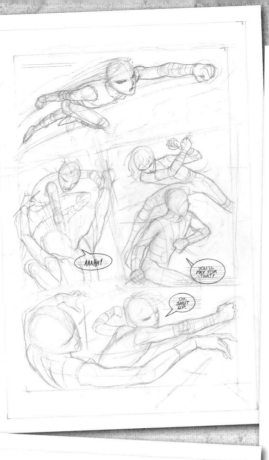

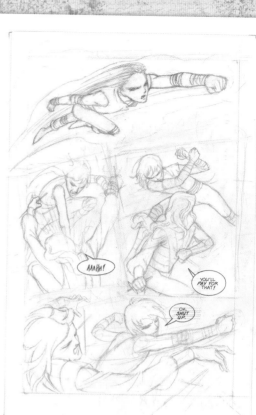

6 Tighten key areas, focusing on places where making a correction in ink would be difficult, such as the facial and hand details. If you make a mistake on dark hair, it can easily be corrected, but delicate lines are hard to fix, so pay the most attention to those areas.

7 Begin inking. The "think in ink" technique is a little like sculpting: You first chip away at areas where you feel the most confident. Focus on areas where your pencil drawing is tightest, and where you will use your most delicate ink lines. Once you have some ink on the paper, you'll begin to see the forms taking shape and you'll feel more confident. The more confident you feel, the better you will be able to tackle more difficult areas.

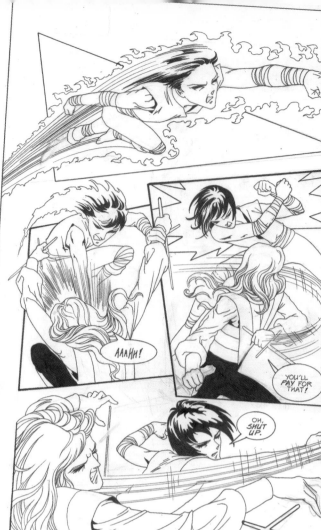

8 In some cases, it's a good idea to ink speed and motion lines before inking the figure details. If you draw the arms or legs first, then add the speed lines over the form, you may have to go back and use correction fluid to remove portions of the body.

Ink the panel boxes after you've drawn the figures and speed lines since some of the figures will break out of the panel boxes.

Use a curved template to create clean speed lines. Keep a firm hold on the template while you run your pen across it. (It's very annoying to have to clean up a stray line, especially if it crosses nice, clean lines you've already inked.)

9 Now that your picture is really taking shape, finish off some of the areas of loose pencil work. Things that looked hard become easy when you just take things in small steps.

Now you can see the advantage to "thinking in ink": You don't have to draw everything on the page twice. And when you ink your own work, you're not only paid more by publishers for doing the work of two people, but you have more control over the finished result. (Some inkers can change the look of your art so much that you'll hardly recognize what you've drawn.)

10 Add a tone with a light pattern to the shirt. If the pattern is too dark, it will cover up the lines on the shirt, which help create a sense of tension and action in the picture.

Tone sheet speed lines contrast nicely with hand-drawn lines and give the picture depth. Look over your drawing carefully and add a few final speed lines or costume details to the legs and arms to make the figure look more energetic.

This final page, completed without tight pencils, took two hours less than the other pages in this book drawn from tighter pencils. That is a savings of ten hours per work week, enough time to draw at least one extra page of art a week!

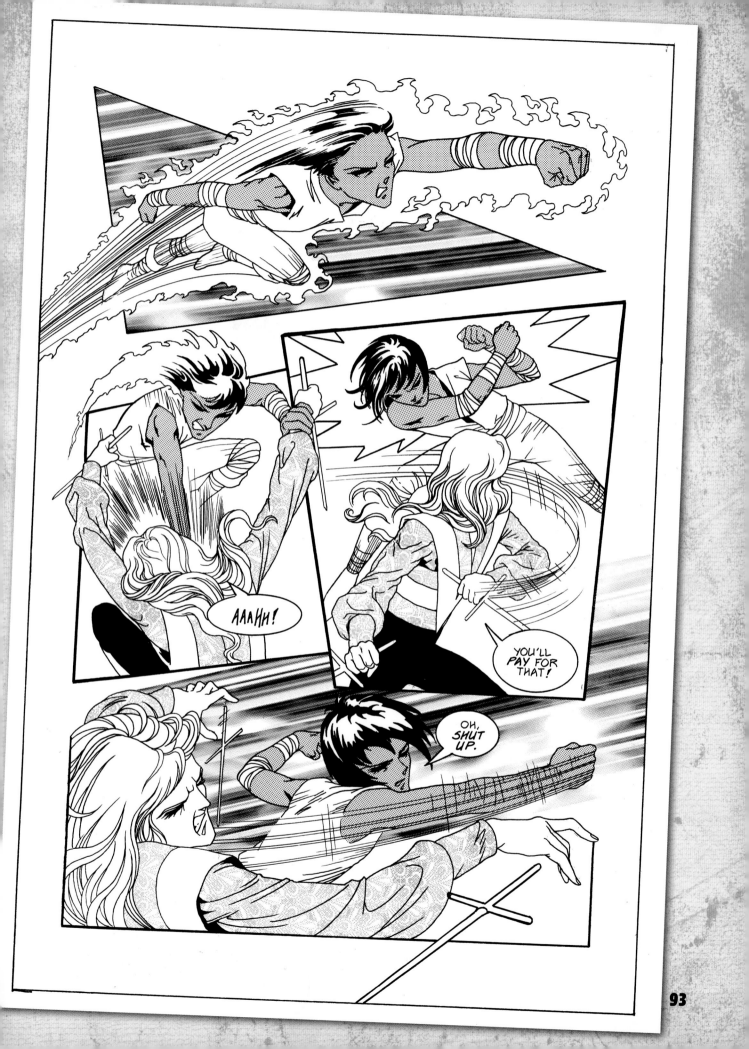

FINISHING TOUCHES

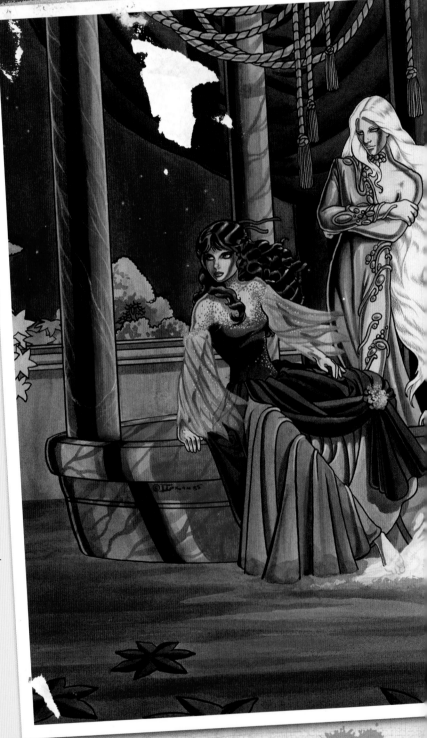

As I noted earlier, much of comic book art published today is colored on computer. To be publishable, the art must be processed using high-quality equipment and software. And if you're with a major comic publisher (and you're not a colorist), you will rarely color your own art. But if you're creating your own OEL or Western comic book, for the fun of it, or if you plan to self-publish your work, you can color your art fairly easily by hand.

The same goes for the cover. Completing a cover painting is the most glamorous part of doing a comic. It's also very important, since it's the first thing people see. That's why publishers hire artists who work exclusively on covers. You want your cover to be a real eye-catcher! We'll take a look at some basic techniques for both coloring and putting together a cover in these few pages.

ART FROM **A DISTANT SOIL** © AND ® COLLEEN DORAN 2007

Coloring a comic page

A great advantage to coloring by hand is that you don't need anything more than a copier, markers and paper. Many of my colored manga pages and illustrations were made exactly as I am about to show you. The good news: It's fast and inexpensive. The bad news: If you make a mistake, you may have to scrap the whole thing and start over, and your word balloons may become seeped with color. You can, however, correct most mistakes with an inexpensive computer, minimal equipment, a little effort and about one hour of training.

Alternatively (and to keep from ruining yo[...] large, original inks), you can make a [...] copy of your art onto high-quali[...] sider carefully what paper you choose [...] working on toned paper, the t[...]es m[...] up too deeply for your taste. I used a c[...]m-colored watercolor paper for this job. You can produce interesting effects coloring on blue, gray or red papers, too. Give it a try.

I reduced the original art by 30 percent. It's easier to color if the art is smaller, but don't make the art smaller than the print size. If your print size is 6" (15cm) high, your art should be no smaller than 8" (20cm) high.

1 *Remove the tone sheets from an earlier page. We'll start off with this simple drawing from page 77.*

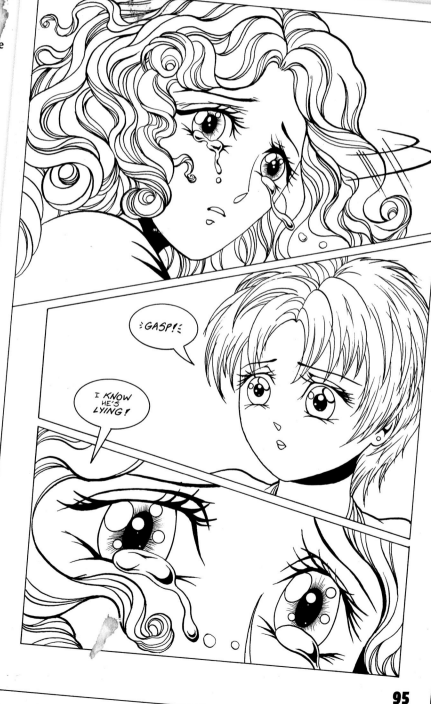

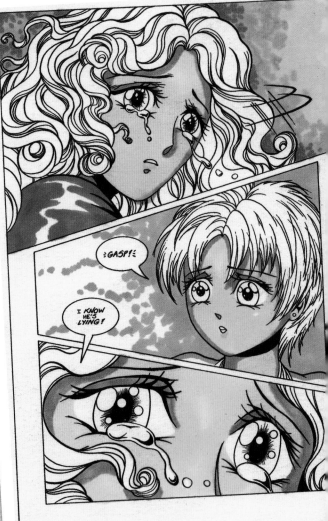

2 Begin with the deepest skin tones using a caramel marker. Use a spring green for the background; green symbolizes jealousy, and Kacey is jealous! Use blocks of color for the background and smooth tones for the faces.

3 Add blotches of an olive drab over the spring green color in Panel 1, then add a yellowish green. Kacey gets a red shirt, and Audra will wear shocking pink. This also helps to symbolize the emotions of the characters. Kacey is red with fury, and Audra is having a shocking secret romance. Add the large skin tone areas smoothly, leaving a bit of white on the faces for highlights.

Notice how Kacey's face color has bled into her hair? No worries. Since her hair is blond, you can just smooth the brown into the shadows of her curls. Don't try to correct a mistake without first thinking of a way to use the mistake to your advantage.

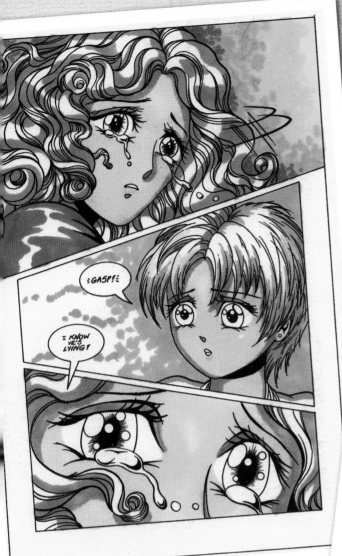

4 Use a sand- or caramel-colored marker for the dark areas of Kacey's hair. Use a medium blue for the dark areas of Audra's hair. Leave wide swaths of paper blank for lighter tones and highlights.

5 To deepen the colors around Kacey's head in Panel 1, add dots using a red marker, then go over the same areas with an olive drab. This green background around her head will make it appear as if she is radiating angry jealousy. Add pale yellow to Kacey's hair in wide swaths, but leave bright highlights blank.

Add a pale blue to Audra's hair, also leaving white highlights blank. Both Kacey and Audra get a touch of the caramel tone in the dark areas of the eye, but Audra will have green eyes, and Kacey will have golden brown. Kacey's hair and eyes are colored using the same colors.

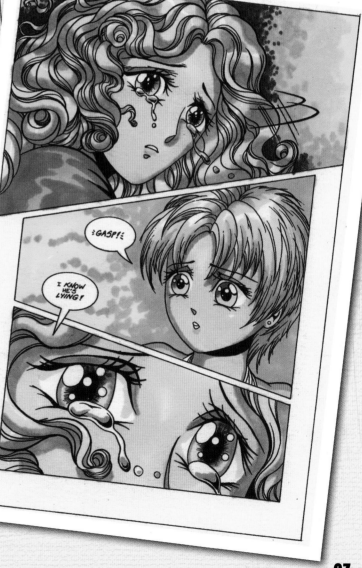

Here's where the advantages of Adobe Photoshop come in: You can smooth out areas of uneven color, make little stray dots of ink disappear, and clean up areas where the colors have bled into the borders or word balloons. You can also add a light lens flare to Kacey's eyes to make them look brighter and moister. A lens flare will give any bright spotlighted color a glow, like the flash off a camera lens.

Making the cover

Use a quality drawing paper such as 148-lb. (315gsm) bristol board. (You'll be making a color drawing, and the marker inks can wrinkle cheap paper.) If you want, you can do your preliminary sketch on inexpensive paper, then transfer your final drawing to better paper using a lightbox.

You can get great, painterly effects with some markers. The better quality marker, the better the effects. Practice with inexpensive markers before you invest in top-quality ones. Regardless, a top-quality set of markers is far less expensive than the same range of colors in paint, and they are great for achieving fast, finished effects on commercial art.

There aren't too many colors in this piece: red, yellow, green and blue, with peach tones for skin. Some of the same colors are used for the hair, stars and clothes. You don't need a lot of colors to get a nice look. Grab a ruler and your felt-tip markers and you're ready to go.

1 *Sketch in the figures. Be loose and free at this stage, and don't worry about making mistakes. Feel free to make as many changes as you want. Your only concern is making a good, energetic sketch.*

2 *Block in the hair and costume details. Again, keep it loose. Begin erasing your guidelines. Check the balance of the facial features to make sure the eyes and jawlines are not lopsided.*

3 If you've drawn your preliminary sketch on another sheet of paper, trace it onto high-quality paper now. You must be careful and clean with a cover sketch. Remember: You are going to go over this picture with color. If you rub too hard with your eraser, or dig too hard into the paper with your pencil, these flaws may show in your final work.

4 Add clean ink lines to your drawing using fine-tipped marker pens. It's extremely difficult to correct mistakes on the original art, so there's little room for error. Be careful.

5 Finish your inked drawing by adding details to hair, filling out eyelashes with smooth strokes, and adding wrinkle lines to the clothing. Spot blacks under the arms, jawlines and around the sleeves. This will add depth to the picture.

6 Color the delicate areas of the skin first—the shadowed areas of the skin around the arms, sleeves, fingers and eyes, and the hairline areas of the face. Give the boy and girl slightly different skin tones by using a pink tone for her and a yellow tone for him.

To create shadows, use dark colors first, leaving large spaces open for the highlighted areas. For the hair, create highlights by leaving wavy streaks of blank paper. For the clothing, leave large areas of the fabric open for the subsequent color. The T-shirt will be yellow, but a light caramel tone looks good for shadow. It's the same color as the hair.

Fill in the skin areas with a lighter skin tone. Leave bits of white paper showing through high on the cheekbones and on the tips of the noses for highlights.

The advantage to creating original art AND having some computer skills is that you can make original art to sell and create nifty effects quickly that will help you meet deadlines.

 Add a slightly lighter red to complete the girl's vest. Use the same red to color the stars. For the boy's shirt, use a bright yellow. Go over the areas carefully to get smooth tones. Use a colorless blender marker to help you smooth out tones. The colorless blender does not add color, but contains a solvent that makes the colors on your paper flow and bleed. They will look as smooth as if you had painted them. Be careful though: You can overuse the blender, causing the tones to flow right outside the lines you have drawn, and that can be hard to correct.

10 To produce deeper and more realistic skin tones, color over areas you've already completed several times. The skin tone will become darker without looking blotchy. For this, use markers with tips that look and feel a lot like paintbrushes. They are great for this kind of work and come in several brands. (For this job, I used the Copic Sketch Markers.)

Use the same yellow you used for the shirt to color the stars. This piece is finished and ready to publish, but you can add a few flourishes with a computer very easily.

103

11 No advanced computer skills are required to touch up your art. For this step, try the Adobe Photoshop tool called the clone stamp.

You use it to copy a small sample of art (such as a colored spot of skin), then create a virtual "paintbrush" to duplicate that spot anywhere you want on your art. In this case, use the clone stamp to clone a white spot, and then use the virtual paintbrush in various sizes as an airbrush to create a sprinkle of stars. Use a larger airbrush to add glow to the hair and highlights to the eyes, then clone key areas of the faces and costumes to smooth out complexions and remove blotches such as areas on the yellow T-shirt.

12 I used Adobe Photoshop's masking tool and gradient color tool to create this funky background effect. But I don't really like it. No worries! If I had painted this entirely by hand, I might be stuck with it.

13 We can delete the background and add another in minutes. You can save each and show them side-by-side to compare, or give them to your client so they can make a choice. You can even save the art in various stages of completion and go back and make any changes you want. While creating original art and working by hand has many terrific advantages, obviously, the same goes for computer art.

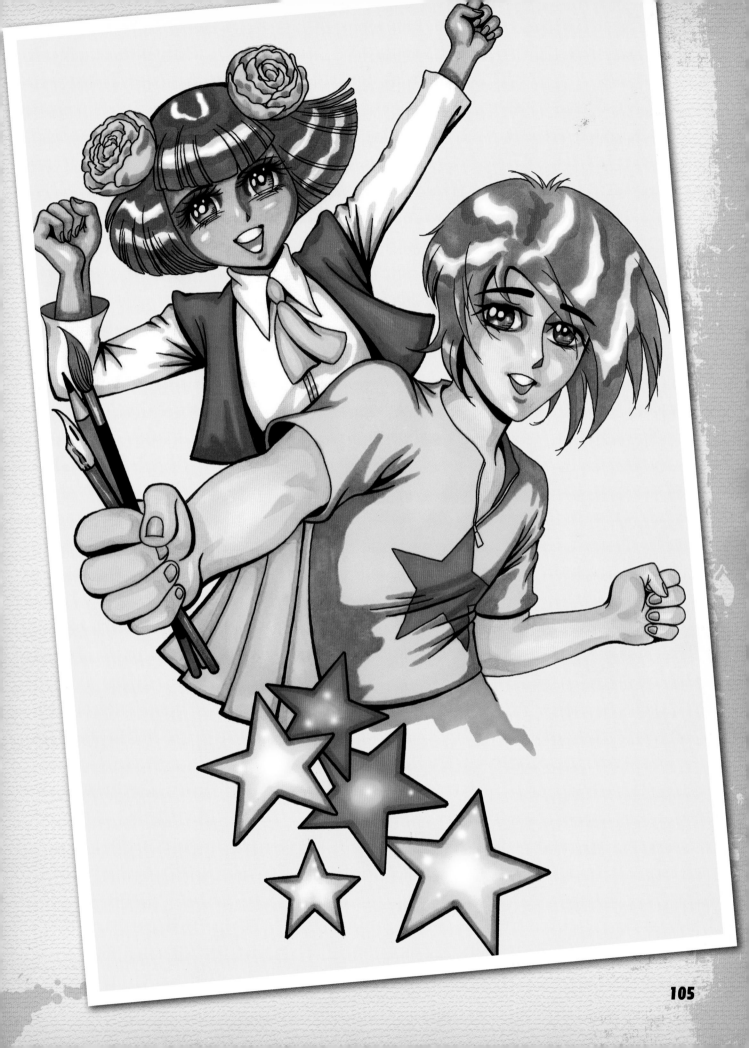

More COMPLEX PAINTINGS

You'll need to do a lot more planning and development when creating more complex paintings. Most mangaka don't get more than a day or so to create finished works, but for covers and some Western-style comics art, you'll get up to a week, and sometimes more. This gives you a lot more freedom to create sketches and to try out your ideas. Whenever you have the time to complete a project, make the best use of it.

Make idea sketches
Make a series of idea sketches that capture the mood or theme of your piece. Develop your ideas as fully as possible. Always carry a sketchbook and jot down every whim.

Sketch from life
The more realistic the work, the more likely you'll need to draw from a model. This live model sketch is an example of what you can create. Sketch from life as often as possible.

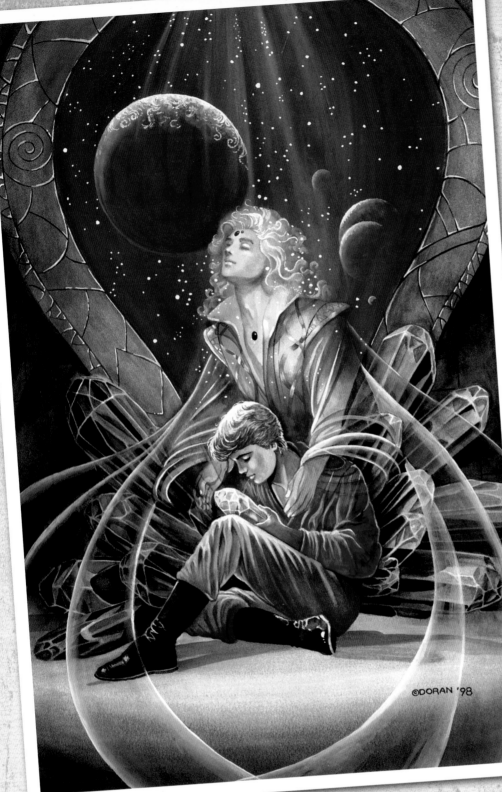

The finished work

The finished cover to A Distant Soil Volume II: The Ascendant. *This took several days to paint. I usually don't get that much time!*

As important as it is for you, as a mangaka, to learn to draw and paint quickly, please take some time to luxuriate in a new piece every once in awhile and give it all the time it needs to be as good as you can make it. Take six months to work on a painting in your spare time.

◄ Make color sketches

Color sketches of your finished ideas are essential. They're not meant to be seen by anyone, and they don't have to be perfect. They're just there for you to test your color ideas. Don't spend too much time on them. Just doodle whatever comes into your mind. When you've settled on a color scheme for your finished work, make a color final sketch right on top of a copy of your final cover drawing. That way, before you start painting, most of your problems are already solved.

PUBLISHING PRIMER

Even if they draw comics primarily for their own entertainment, most artists would really love to see their work published.

Fortunately, there's no better time to publish your comics, as there are more publishers producing graphic novels than ever before.

Self-publishing is always an option (I self-published my comic A DISTANT SOIL for six years before I took it to Image Comics), and Web publishing is relatively inexpensive compared to print self-publishing. Many cartoonists who started out posting their work on their own websites or blogs later went on to work with major publishers. Don't assume that there's only one option available to you. If one way doesn't work, you can always try another. Don't fall in love with one idea or one dream. Be flexible and willing to experiment with different publishing opportunities.

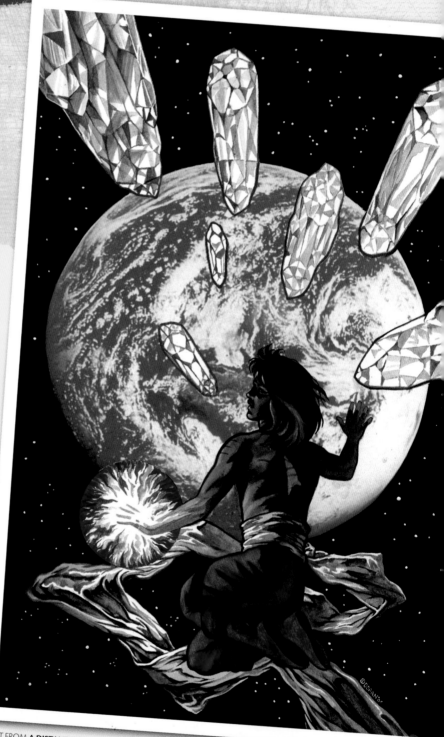

ART FROM **A DISTANT SOIL** © AND ® COLLEEN DORAN 2007

KNOW WHAT YOU WANT, KNOW WHAT THEY WANT

Research your options carefully. Know what you want for your comics and for your future. Don't focus exclusively on manga publishers just because you create manga. There are many companies that publish manga-style work.

Every publisher is looking for different art styles and has different standards and specifications. Sometimes publishers realize they are stuck in a rut and want to try new things! Maybe that new thing will be you.

WHAT NOT TO DO

Always make your portfolio meet the standards of the publisher you're hoping to impress. Here's something that happened to me years ago that may be a lesson for you as it was for me. Before going to this conference, my agent, Spencer Beck, advised me to target my submissions. So, we researched in advance to present specific samples to specific editors.

I managed to get a rare meeting with the art director of DC Comics. This wasn't easy to do. Most artists never get to meet with the art director. They usually deal only with editors. For this meeting, I opted to ignore my agent's advice, wanting to show the art director how versatile I was.

Since I work in many different styles, I filled my portfolio with about forty different pieces of art showcasing all those styles. Wouldn't I have a better chance of getting a job if I showed many types of work?

Well, not necessarily.

The minute the art director saw certain samples, he blurted, "I hate that stuff! Don't show that to me, I don't even want to look at it!" and flung the samples aside.

While he complimented some work, he was openly hostile to much of it. When the review was over, I was shaking. He barely mentioned what he liked about my work and could only remember what he didn't like.

I had ignored my agent's advice and bombarded this art director with everything I had. Bad call! Between the two meetings, Spencer and I had lunch and discussed what I had done wrong. I resolved to stick with his advice in the future.

RESEARCH PAYS

The same day, I had a portfolio review with several different editors at Marvel Comics. Before I went to my meetings, I made sure I divided the art in my portfolio into three sets. Each set of samples was picked to meet the tastes of the editors.

My first meeting was with Mike Marts. I knew he liked manga, so I made sure he saw those samples. The second editor liked fantasy, so I showed her fantasy samples as well as the superhero samples. I showed only superhero samples to the third editor.

And what do you know?

No one had any complaints. In fact, two out of three editors hired me within a week. By simply tailoring my samples to show the editors the kind of work I knew they would like, I was able to pick up a huge amount of comic work in one day.

Editors see so many samples, and are bombarded with so much information, that they need clarity from you. They need to know what to expect, and they can be confused by large sample packs and a wide variety of styles.

So for starters, keep it simple. Stick to one set of samples you know the editor will like. If they want to see more, then become more adventurous.

(Later, I had a much better portfolio to show my DC editors and have worked there steadily ever since. So, even if you screw up, don't give up. Come back another day and give it another try!)

ANCIENT COMIC INDUSTRY SAYING

"There are three things you need to make it in comics. You need to be talented; you need to get along with people; and you need to make deadlines. But you only need two out of the three."

The fact of the matter is that many talented people simply do not have the personal discipline, the ability to get along with others, or the patience to make it as professionals.

How do I Meet An Editor?

The best place to meet an editor is at a comics, anime or manga convention. Many editors stage portfolio reviews to seek out new talent. I picked up all of my first comics and illustration work by attending conventions and showing my work to publishers and editors. My first jobs actually came from the editors I met at science fiction conventions when I was fifteen years old. The conventions scene can work for you, too.

Go where the editors are
The San Diego Comic Con International is the #1 comic convention in the U.S., with over 125,000 attendees.

WHAT IF I CAN'T GET TO A CONVENTION?

It's harder to make an impression this way, but the old-fashioned method for getting an editor to look at your stuff is by sending samples through the mail. Editors get a lot of mail, so often the best way to get their attention is to mail samples to their assistants. Because editorial assistants and assistant editors don't get as much mail, they tend to read and pay more attention to the mail they do get. They can then show an editor promising samples.

CHOOSING AN EDITOR

Pay attention to the editorial credits in books that you read and enjoy. If you think the editor (or his assistant) and you are of like minds, this may be the editor to focus on.

The mailing address of the publisher can be found in most copies of every book you buy. Don't mistake it for the subscription office, however!

Some editors and publishers don't look at samples at all. Don't even think of sending them your work—they will just throw it in the trash. Why waste your time, energy and postage?

How do you know who's looking for artists and who isn't?

The best way to find out who is seeking artists is to go to a publisher's website and look up their submission guidelines. Almost every publisher has submission guidelines clearly spelled out for you. Even if you don't own a computer, you can look up your favorite publisher at a local library.

If you carefully follow the publisher's submission guidelines, you are one step ahead of the game. The fact is, only a small fraction of aspiring writers and artists ever bother to read the directions in the submissions guidelines. Every publisher has different specifications, and nothing annoys editors more than the realization that you haven't paid attention to their simple instructions. If you indicate from the start that you can't follow instructions, it's not a promising indication of your future performance.

To make sure the editor receives your samples, enclose a self-addressed postcard that can be returned to you. Don't send samples by an expensive courier service.

Follow up about every eight weeks with more samples or a nice note. Don't email your samples to anyone unless they ask you to. Unknown emails with attachments usually go in the trash.

PATIENCE

Patience is not only a virtue, it's a necessity. After submitting your work to an editor, you may wait months before you hear from them. Don't pester the editor, and don't lose your temper.

The PORTFOLIO REVIEW

Again, the best way to get a publisher's attention is to go to conventions and get portfolio reviews. Begin doing this as soon as and as often as possible. Find artists whose work you like, and ask them to look at yours. Tell them you're serious and want to know how to improve as an artist. If you are very young, artists may be afraid of hurting your feelings and may tell you what they think you want to hear. Don't settle for that. Get the truth.

Getting critiques of your work from an early age will help you to get used to accepting criticism, and it will help you learn. The earlier you know where your strengths and weaknesses are, the better.

Many schools don't teach how to draw properly, and fewer still teach anything about sequential art. You're on your own, most likely. Fortunately, there are many books available that can help (see page 124).

At a convention, you will probably only be able to snag a couple of major portfolio reviews...if you are lucky. Being able to see more than a couple of editors from major houses to give them your sample packets is unlikely. (See page 109 for tips on preparing for reviews from editors at the big publishers.)

If you plan to get portfolio reviews from several smaller publishers or from other artists, you probably won't be able to custom-design a separate package for each one. No one will require that of you. That's something you should do for mail-in samples.

If you don't feel you're ready to be published, don't approach an editor. Editors are looking to hire talent, and if you know you're not ready to be hired, you're not being fair to the editor or to the other artists.

If you're just looking for a critique, approach artists whose work you like instead. Many artists will not look at portfolios, but some will, and many conventions have an Artist's Alley.

Get opinions from a variety of pros. Don't just listen to one and quit, especially if the response wasn't favorable. You must march on, no matter what. Moreover, if different people are telling you the same things about your work, then you may have a problem that's worth addressing. Be flexible and willing to make changes, even with the elements of your work you love most. All artists, no matter how successful, have to make changes while on assignment. Don't fall in love with yourself—fall in love with the idea of doing a better job.

Whether you're seeking portfolio reviews with editors or professional artists, follow these tips for the best results.

WHAT TO PUT IN YOUR PORTFOLIO

▶ A variety of pages that show you can draw action sequences and that show you understand character and body language.

▶ A couple of pages that show people standing around and talking, doing normal activities. No matter how fantastical the comics, there are always quiet moments, and you'd be surprised how many artists can't draw them.

▶ A few pages that show off your knowledge of how to draw perspective. You don't have to be a master of perspective to be a cartoonist. You must, however, know enough about it to draw convincingly.

▶ Some sample pages that show how well you draw a variety of people. Not everyone will be young and glamorous. Even if the main cast is, the people on the street won't be.

▶ Your very best work. Never, ever put anything in your portfolio that you're not one hundred percent proud of. Don't put in old work for which you feel you need to explain or apologize.

▶ No more than about a dozen pages of samples. Too many samples will overwhelm editors. They have a lot of people to see and only need a taste of what you can do.

INKER PORTFOLIO NOTE

If you're submitting samples as an inker, submit both the final inked art and the pencil art you drew from. If you're not a good penciler, that's OK. Either find another artist who's a better penciler than you and ask if you can use his pencil samples, or download samples of pro pencilers' art from their websites. Place the art on a lightbox and do your inking on the top sheet. Then submit the copy of the pencil art along with your inked version. Always credit the penciler. It's perfectly legal to practice on another artist's work this way, as long as you don't try to sell or market the work. You're showcasing your inking skills. In fact, some publishers will provide copies of pencil art for you to practice on. It never hurts to ask.

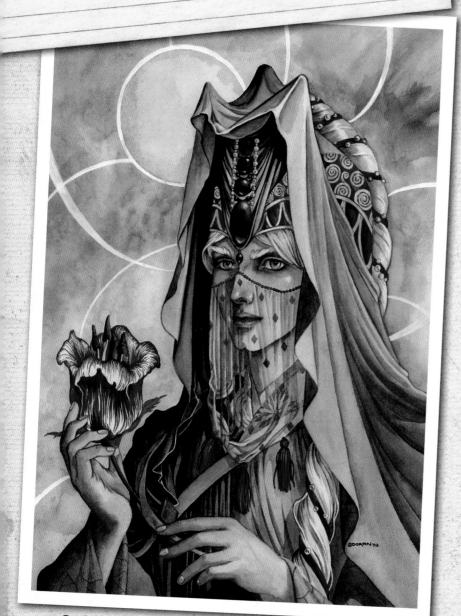

Don't fill your portfolio with only pinups

WHAT NOT TO PUT IN YOUR PORTFOLIO

▶ All pinups! This is the absolute worst mistake ever. I've seen many portfolios by aspiring comic artists, and to my astonishment, very few of them contain comic pages. They have beautifully painted figures, but these don't tell an editor anything about your ability to draw comics. Comics are about telling a story, so be sure to include good, solid, clean and clear storytelling in your portfolio.

▶ Lettering. Unless you are a letterer, do not add lettering to your samples for publishers. Editors hate that. Most publishers use in-house letterers, and if your lettering isn't absolute pro quality, they don't want to see it on art. It can make good art look amateurish.

▶ Art that doesn't display your strength. If want a job as a penciler, then just show *pencils*. Do *not* put painted art, inking or anything else in the portfolio. Focus on your strength and show *only* that.

MAKING THE MOST OF A REVIEW

Get portfolio reviews from as many editors or artists as you can. If there are ten editors you think might like your work, then skip the fun convention activities and see the editors. Keep these things in mind to make the most of the time you manage to get with an editor or artist.

▶ DO NOT ARGUE, DO NOT PLEAD. Whatever you do, do not apologize for your work. And pay attention. If you expect them to look, they'll expect you to listen. Criticism can be hard to take, but you must learn to accept it. You'll be receiving it for the rest of your life. Remember, they are doing you a favor. Do them the courtesy of

SPEED: HOW FAST ARE YOU?

You can have the most beautiful portfolio of comics pages in the world, but if you can't work quickly, you can't work in this business. This is a deadline-oriented industry. It is unforgiving, it is brutal, and it is the most fun you'll ever have working like a dog. But it requires the ability to produce consistently.

To be a professional comic-book artist, you must be able to draw about twenty-five pages of finished comic art a month (and that's on the low end of the production scale). Major mangaka in Japan produce hundreds of pages per month. Manga artists in the U.S. usually draw between 160 and 300 pages a year.

Can you draw twenty-five pages every month all by yourself? That means producing a finished, original piece of art almost every single day.

accepting what they have to say, even if you don't agree with it.

▶ DO NOT BAD-MOUTH. If you feel someone has been unfair or unnecessarily harsh about your work, move on. Don't have a fit, and don't go online and criticize. Just go to the next person. Whatever you do, don't bad-mouth the pros you've met, especially by writing about them on your blog. It's a small world and word gets around. You don't want to offend people and make enemies when you're trying to get started. Sometimes it's best to keep your opinions to yourself.

▶ DO NOT DRESS IN COSTUME. Don't wear inappropriate, sexy clothes, either. Don't be slovenly. Be neat and professional. This doesn't mean you have to wear a suit, but I can't tell you how many times I've heard editors comment on the way aspiring artists dress. Some editors are so put off by an artist's ridiculous appearance that they can't remember what they were supposed to be looking at. You want to be noticed and remembered for your work, not because you wore something goofy.

▶ DO LEAVE HARD COPIES ALONG WITH DISKS. If you leave a disk, leave a few pages of hard copy as well. Some editors don't like to look at disks because they fear computer viruses or just because they don't want to go to the trouble of firing up the computer to look at the art.

▶ DO HAVE SAMPLE PACKETS. Get some large envelopes (8½" × 11" [22cm × 28cm]) and make sample packets to leave with promising publishers and editors. Staple your pages together, and put your contact information directly on your art. Include your name, address, phone, Web address and email.

▶ DO PREPARE SEPARATE PACKETS. If one of your styles is manga, and another is superhero, have separate packets of each to leave with clients. If an editor expresses interest in seeing a variety of work from you, then leave more. Otherwise, only show clients what they want.

▶ RESEARCH PEOPLE BEFORE APPROACHING THEM. Before you approach an editor, first take the time to read some of what that editor edits. And if you approach an artist, nothing is more insulting than letting that artist know you don't actually read their work.

The INTERNET is ONE BIG CONVENTION

There's another way to get editors' attention and to get your work published, and you don't have to go to a convention or mail anything. Every moment of the day and night, there are millions of fans in chat rooms, on websites, on blogs, and on fan forums talking about comics, showing their work and meeting pros.

A great way to attention is to participate in fan activity (Fanac) online. You can either start a blog or find a friendly, welcoming fan forum site to discuss comics. Many aspiring pros and top professionals meet there. If you have a scanner, you can occasionally post your art to fan websites and discussion areas. I have two websites, but I also post a series directly on my blog. I post one page of my story *A Distant Soil: Seasons of Spring* weekly. Clients have hired me because of the work posted on my website and blog. Top manga creator Svetlana Chmakova was scouted by Tokyopop after they saw her work online.

Anyone with access to a computer and scanner, and who has an email account, can publish online. Merely having a livejournal or a blog is a form of publishing. If you can't afford your own equipment, borrow it or use it at school. One thing's for sure, for far less than the cost of printing one issue of a self-published comic, you can buy all you need to publish on the Web.

Most of the artists I know have a website that showcases their work. If you can't create one yourself, or you can't afford the hosting fees, you can post on your livejournal or blog.

You probably won't make any money posting your stories and art online, but the point is to get readers interested in your work. After I started posting my story on my blog, my traffic increased ten times! And, publishers and editors pay attention to stuff they see while surfing the Web.

There are also websites that showcase online comics. Some post comics to paid subscribers; others post the content for free and take donations or make money through advertising. Again, no one is getting rich doing this, but some creators have become successful enough to be able to print their books.

There are also online art communities that host portfolios for artists. Interested parties can peruse samples of various works in different mediums and genres. This is a low-cost and easy option for getting your work seen.

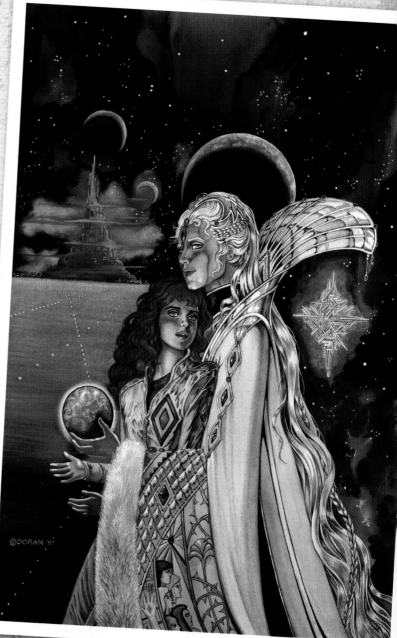

ART FROM **A DISTANT SOIL** © AND ® COLLEEN DORAN 2007

CREATING ART for a WEBCOMIC

Creating art for the Internet is exciting and fun because you can reach a huge audience, you don't need a publisher, and you don't have the expense of self-publishing in book format. Additionally, you can generally paint in any way you want. Some publishers have actually forbidden me to work in colored pencil, for example (they don't like how it prints). But it looks smooth on a computer screen because most art posted on computer is scanned at only 72 dpi (most of the color art for a book is scanned at 300 dpi). Tiny flaws that show in print disappear on the computer.

There are a few things to keep in mind when creating art specifically for the Web.

ART SIZING

Create your art so that it fits the screen of a computer, not so that it conforms to the size of a book. It also helps to create each panel of the comic on a separate piece of paper and to make each panel to be seen one at a time on the screen.

In general, a comic book page will be longer than it is wide, but a Web page will be wider than it is long. There is a great deal of variation in the size of computer screens, so it is tricky to determine the best proportion for all of them. I find that pages that measure about 460 pixels work best if you have a weblog, and you just want to upload your pages to your weblog. An entire comic book page drawn in the Western size and style looks a little cramped at that size. So, as you see from the single panel on this page, one panel per page is shown at a time. The original art is drawn at 9" (23cm)

and is large enough to see easily on the computer screen. There are a number of programs for uploading comic art that can help you decide what size works best for you.

SCANNING AND SAVING

Monitors and paper show color differently. For that reason, there is one way of scanning art for printing, and one way of scanning art for the computer. Monitors create color using red, green and blue. So for computer art, you must scan and save your art in RGB color mode. Printers create color that can be seen on paper using cyan, magenta, yellow and black. So art for print is saved using CMYK.

OTHER WEB CONCERNS

Since your art will be scanned at a low resolution, your lettering must be very clear to be legible. Keep in mind how the art will look on screen. Look at other Webcomics. Are they clean and clear? Are the pictures too small? Are there too many images on the screen? Is it easier to read one picture at a time, or to look at art drawn the same way as traditional comics pages? Every time you look at a new Webcomic, close your eyes for a second or two, then open them. Consider your first impression of what you see. That is the same reaction strangers will have to seeing your art for the first time on the Web. You will be creating comics for total strangers to see. Always give them a good first impression.

Webcomics give you medium freedom
This art is from the Webcomic Superidol, written by Warren Ellis, who allowed me to reprint this sample of the story.

Here, I painted the background in watercolor, then used a textured tone sheet and paste it right over the original art!

Fanzines & Minicomics: THE ULTIMATE IN GRASSROOTS PUBLISHING

Many artists began their careers doing fanzines and minicomics. A publisher may very well take you more seriously if you've gone to the trouble of putting your work into print form. Moreover, creating a fanzine or minicomic shows that you can create a comic from start to finish. This gives you an advantage over artists who have nice portfolios, but have never drawn ten pages of story and art. Many publishers, editors and creators read blogs, fan forums and news sites; they look at fanzines and minicomics.

THE FANZINE

Amateur fan presses have been around for many years. Serious manga fans are familiar with doujinshi, or fanzines, fan-published magazines—sometimes just stapled together—of comics, articles or other material.

I started out in fanzines. I was a big fan of *The Legion of Super Heroes* when I was a kid and wrote and drew stories in a fanzine. I was shocked to learn that the creators of *Legion* at DC Comics also read the fanzine! Then, the artist of *Legion*, Keith Giffen, called to ask if I wanted to draw the book. Later, I actually got the gig. This is an example of how publishers, artists and editors are often very welcoming and supportive.

THE MINICOMIC

The minicomic is a fun, inexpensive way to get a taste of publishing. Give yourself an assignment, set deadlines, then enjoy selling your work at shows and sharing it with friends. Seek out local comics retailers who support local artists. (A fair split between you and the comic shop is 50/50.) All you need is sixteen pages of art and story and access to a copy machine.

You can reduce your comic art pages to fit and paste onto halves of an 8½" × 11" (22cm × 28cm) or an 11" × 17" (28cm × 43cm) piece of paper. Some artists draw their original pages to fit the format in which the pages will be copied. The pages are sandwiched with pages 1 and 16 next to each other, pages 2 and 15 next to each other, and so on. When they're folded together, they read in the correct order. Staple the pages on the crease using a stapler with a very long handle (found at office supply stores).

The best minicomics are avidly collected. Artists create beautiful works in this format, sometimes decorated with ribbon or colored by hand. These books can be found at conventions such as those held at the Museum of Comic and Cartoon Art (MoCCA) and the Small Press Expo.

ATTITUDE

Aspiring artists or writers who carry themselves well in public will be noticed. Their art will be noticed. Graceful behavior in the midst of online conflicts is especially telling to editors. If you are the kind of person who bad-mouths other artists and writers and is impolite to others—people don't forget. If you treat your fellow fans that way, you may treat your fellow pros that way.

So, drop the snark and snide. Don't write things online that can come back to haunt you. You may end up working with one of the people you are sneering at on your blog. And let's face it … everyone makes mistakes. So, some editor did something you didn't like. An artist didn't pay attention to you. You didn't like that story someone wrote. If you wouldn't want it said about you, don't say it about others.

16-page minicomic layout
Assembling a minicomic is easy! Pages 1 and 16 sit next to one another, with pages 2 and 15 on the opposite sides, and so on.

Fanzines and Minicomics Are a Great Beginning
This fanzine, for which I did the cover, was called Nova, and the art was based on a shoujo manga called Patalliro. It was produced by the Earth Defense Command Animation Society. This issue included articles about The Tale of Genji, Space Cruiser Yamato, Kimba the White Lion, and a few pages of translated manga. It can be a real advantage to have a handsomely produced 'zine that features your art and writing to hand to a potential client.

The RISKY BUSINESS of SELF-PUBLISHING

Actual self-publishing is a bit different from producing fanzines or minicomics. Unlike creating a minicomic (intended to be sold locally or at shows), self-publishing involves managing inventory and working with printers, distributors and retailers.

I was a part of the early self-publishing movement in American comics, along with Jeff Smith, Dave Sim, James Owen, Steve Bissette, Rick Veitch and others.

Maybe you'll end up becoming wildly successful like Kevin Eastman and Peter Laird, the creators of *Teenage Mutant Ninja Turtles*. Jeff Smith created *Bone*, another very successful comic series. He eventually gave up self-publishing and took his series to Scholastic Books where it has sold over a million copies. I also gave up self-publishing and took my series, *A Distant Soil*, to Image Comics.

Unfortunately, the success stories really are exceptions. Self-publishing is a major financial risk. Almost everyone I know who tried it lost every penny and more.

A comic from a printer, with a color cover and good quality paper, can easily cost well over one dollar per copy. Most printers have minimum print runs of five hundred to one thousand copies. The more copies you print, the lower the unit cost. The fewer copies you print, the higher the unit cost. That is, printing one thousand copies may cost $1.60 a copy, but printing three thousand copies may cost $1.30 a copy. However, printing three thousand copies will cost $3,900 and printing one thousand copies will cost you $1,600. Be sure you can sell that many before you sign on. Printing more copies than you need with the aim of saving money in the long run puts you at great risk of being out a lot of money in the short and long run!

In the end, I can't recommend print self-publishing, unless you have a lot of money you can afford to lose.

STEPS TO SELF-PUBLISHING

If you're not deterred by the risks and still want to self-publish, what you learn here can really help you.

1 STUDY There are lots of self-publishers online, and many top comics creators have self-published. Investigate their websites and ask them anything you like. Look for books about self-publishing. Attend conventions and ask questions. Find out the most common sizes for printing a comic.

2 SAVE MONEY You need enough money to pay for your overhead expenses while producing your comic, as well as to pay for the time you put into the comic.

3 COMPLETE AT LEAST ONE ISSUE OF YOUR COMIC Many of the distributors require that you turn in a copy of your comic for their review before they decide to carry your comic in the catalogues. If a major distributor won't carry you (the biggest is Diamond Comics), you might want to consider print-on-demand publishing (Cafepress.com is a good option) or publishing on the Web.

4 KEEP COSTS LOW Spending a lot of money on advertising and promotion is not always the best way to go. Your best bet is to promote yourself online or to produce minicomics you can give away as samples. Do not go for expensive paper and cover stock when printing your books. No one ever sold a comic book because it had great paper.

5 BE PATIENT For most people, there is no financial payoff in self-publishing. However, the satisfaction of seeing other people read and enjoy your work is immeasurable. Some people seem to have instant success. Others take years to get off the ground. Remember, you did your comic because you wanted to make a comic, not because you wanted to get rich.

For more information about self-publishing, check out this source: www.members.shaw.ca/creatingcomics/publishing.html.

How your book GETS TO COMIC SHOPS

You must go through an approval process with the major comics distributors if you want to see your book in comic shops across the country. In exchange for distributing your book, distributors keep about sixty percent of the retail price. And, to get the comic shops to order your comic, you will need to advertise and promote it.

HOW TO APPROACH DISTRIBUTORS

Begin the approval process with a distributor by sending a complete copy of your first comic along with a professional cover letter about your company to the submissions coordinator of the distributor. A photocopied version is fine, but lettering and final cover design should be included. If you have the second and third issues for your comic as well, so much the better. (Your submissions will not be returned.)

Remember, you do not have to send a finished printed copy. Moreover, if you are going to publish your comics, you should never go to print until you have your orders in from your distributor. (See The Purchase Order.)

THE PREVIEWS CATALOG

Once a distributor agrees to carry your book, they put you in the *Previews Catalog*. Comics are ordered by retailers from this huge book that lists all the products the distributor is selling that month. There are well over one thousand comics listed every single month. If your orders fall below a minimum sales threshold (usually about three hundred to five hundred copies) the distributor will drop you, and you won't be carried in comic shops anymore. (And that will probably sink your company.)

If a distributor agrees to carry your comic book, then, months before it's published, you send the distributor a copy of your cover art and information about your comic, including cover price, publication date, story content, etc. Just go to a comic shop and ask for a copy of the *Previews Catalog*. You'll see how other comics are listed so you'll get an idea of what the distributor needs from you.

THE PURCHASE ORDER

About two months later, your distributor (or distributors, if you're lucky) will send you a purchase order. *Never, ever print your comic before getting a purchase order*. If you go to press with three thousand comics and you get orders for four hundred books, you'll have something to cry about. Overprinting and getting stuck with big stacks of unsold books has sunk many a small press.

BE READY!

It takes time to print a comic, so it's important that the book be ready to go to press as soon as the orders come in. Your printer has a lot of other books to print and must schedule time for you. Some publishers even send their books overseas, and it can take six months or more to ship them to stores.

DISTRIBUTOR CONTACTS

Diamond Comics Distributors
www.diamondcomics.com
Attn: Submissions Coordinator
1966 Greenspring Dr., Suite 300
Timonium, MD 21903

Cold Cut
www.coldcut.com
Submissions Director
Cold Cut Distribution
220 N. Main St.
Salinas, CA 93901
phone: 831-751-7300
fax: 831-751-1513

Diamond is the biggest distributor, but Cold Cut is especially friendly to small, start-up companies. Cold Cut's website is also a great resource for new publishers and self-publishers. It includes information on retailers who support small-press companies.

Legal and information resources

Always try to maintain ownership of your copyright and trademark. If you do decide to sell these rights, proceed carefully and hold out for the most money possible. Once you sign away your rights, it's almost impossible to get them back. Your project won't be yours anymore.

Never sign anything with a publisher, agent or anyone else without first consulting an attorney. I don't care how poor you are: Get an attorney to look at your contract (some will do it for free). Not just any lawyer will do. All lawyers specialize. The inexperienced attorney can only look at your contract and tell you whether the language is legal. He can't tell you whether or not the contract is in your best interests.

Look at the problem this way: It's perfectly legal to sell your house for ten dollars. Do you want to sell your house for ten dollars? Of course not. But it's legal to do so.

There are publishing contracts that basically ensure that you, the creator, get paid nothing for all of your work. These contracts are legal. A savvy lawyer will know how to prevent this from happening to you. An inexperienced lawyer will not.

Check out: VOLUNTEER LAWYERS FOR THE ARTS at www.VLANY.org.

COPYRIGHT INFORMATION

A copyright simply means the right to copy. That is all it means.

You, the creator, are endowed with the copyright to your work the minute you create it. People will tell you that you have to get some kind of post office stamp or other nonsense to register a copyright. Not so. The only way to register a copyright is with the U.S. Copyright Office. Registration affords you greater rights and privileges under the law, but nonregistration does not remove your copyright. As long as you have written or drawn something—published or not—you own the copyright, and no one can take it from you without your approval.

Copyright is actually a bundle of rights that you can keep for yourself or lease out one by one. Every form of reproduction, whether online on a blog, on TV, or by photocopy machine, is a different copyright. Creators make money by leasing or selling their copyrights. It's usually in your best interests to lease it out instead of selling it outright.

And please remember: You cannot copyright an idea. You can only copyright the execution of an idea. No one can be sued successfully for using an idea you thought of yourself.

And you can't sue people for using an idea similar to yours. There are five billion people on this planet. You're not the only one who ever dreamed up that story about a fairy princess, a thief and a magic sword.

For questions about copyright law, go to: The U.S. Copyright Office website at www.copyright.gov.

There is an extensive Frequently Asked Questions (FAQ) page that tells you every thing you'll ever need to know as a creator. Don't ask fans or pros in online forums. Few pros know what they should about copyright law, and fewer fans do.

TRADEMARK INFORMATION

Your trademark is just as important—if not more important—than your copyright.

Copyright protects writing and art, but trademark protects symbols of commerce. A trademark is the mark of one's trade. You've seen the TM symbol or ® next to a title or picture of a character. The TM symbolizes the intent to trademark. The ® symbolizes a registered trademark on file with the government.

Think of a trademark in terms of a town with three taverns: The Boar's Head Tavern, The Sheep's Head Tavern and The Horse Head Tavern. Each tavern has a picture of the named animal over the door of their establishment and stamped on the cask of each barrel of ale they sell.

Now, The Horse Head Tavern sells the best ale in the county and everyone knows it. The folks at The Boar's Head Tavern don't like losing all that business. So, they decide to start stamp-

VANITY PRESSES

Please avoid "vanity presses" or any publisher that charges you, the artist, to publish your books. No real publisher charges creators to publish. Moreover, there are editorial services that claim they can read your work and get it published for a fee. Avoid them.

120

ing their inferior casks of ale with a horse head, the *trademark* of The Horse Head Tavern. The horse symbol is the *mark* of *trade* for The Horse Head Tavern. Everyone knows that the best ale comes from The Horse Head Tavern and expects that when they see a horse head on a cask of ale, they get the best- quality drink.

The Boar's Head Tavern is diluting the brand of The Horse Head Tavern by falsely identifying the source of the goods. They are selling bad ale that appears to come from The Horse Head Tavern but doesn't. And they are creating confusion in the marketplace.

People stop buying Horse Head Ale because they have confused it with the inferior brand sold by The Boar's Head Tavern. The Horse Head Tavern loses business and goes under. The Boar's Head Tavern still sells stinky ale and begins marking their casks with the sheep's head, trying to steal their business, too. The Sheep's Head Tavern has better lawyers than The Horse Head Tavern, figures out what's going on, and sues The Boar's Head Tavern for trademark infringement. The Boar's Head Tavern has to cease and desist, destroy all the fake ale, and pay damages.

The title logo design of your book is a symbol of commerce. It must be trademarked to protect that symbol. Your character designs are symbols of commerce. A specific symbol such as the Superman chest S is a trademark. A typical Superman figure design as seen on a T-shirt would be trademarked.

You indicate your intent to register a trademark with the U.S. Patent and Trademark Office by putting a ™ next to a symbol. When that trademark has been filed, you get to put an ® symbol next to it. The ® has a lot of legal power. It takes a lot of time and money to register, though. And it's easy to make a mistake on the paperwork, so get a lawyer. It costs more, but even with a lawyer, I had to file the paperwork twice to meet the trademark office standards for *A Distant Soil*.

What does trademark mean to you?

It means better than half the value of your work. If you sign away the trademarks in your project, the publisher owns your title, logo and character names and designs, even if you're still the copyright holder. You can be dismissed from your own project, and someone else can be hired to write and draw it without you.

Some publishers will try to get you to sign away your trademark, claiming they need it to market and sell your work. Don't take your publisher's—or their lawyer's—word for anything when it comes to your rights. Visit the United States Patent and Trademark Office website and read the FAQ page:

www.uspto.gov

THE GRAPHIC ARTISTS GUILD

There are many benefits to being a Guild member, and membership is open to students for a much lower membership fee. In addition to an informative newsletter and access to health care, you can also subscribe to the JobLine, a nationwide listing of art and design job openings. You will learn a great deal about being a professional artist by being a member of the Guild. I highly recommend it for every artist. Visit their website at www.gag.org.

ABOUT PRINT ON DEMAND

I am not going to tell you to do it or not to do it. I know some artists and authors who've had good results with print on demand. However, it's easy to make bad choices.

The Science Fiction Writers Association has an extensive article on the print-on-demand publishing phenomenon on their website at: www.sfwa.org/beware. Make an informed choice.

If you're still interested in print on demand, visit the site below for a comprehensive, side by side comparison of Print on Demand Services. The wide variety of charges, along with what the different publishers expect to get (and what some don't expect to give) is rather eye-opening. www.dehanna.com/database.html

TRICKY LANGUAGE SAFETY TIP

There's a little trick some publishers will use to try to get you to give up your trademark without your knowing it.

The contract will not specifically state that you're signing your trademark over to the publisher, but it may include a clause that will say, "the Creator cannot register the trademark in his or her own name." This is considered trademark abandonment. If you agree to abandon the trademark, then the publisher can claim the trademark for itself, and you lose it without actually having directly assigned it. Lots of creators have made this mistake.

More resources

I can only recommend books, websites, publishers and conventions with which I have personal experience. There are many other great publishers, conventions and sites out there. Don't be shy! Do some research and make your own decisions.

COMIC CONVENTIONS

The big conventions are the San Diego Comic Con and the New York Comic Con. These are attended by every major publisher, many of the small ones and tens of thousands of fans, as well as most of the professional community. The advantage to attending is that everything cool is there. The disadvantage is that you have a lot of competition for attention. Everyone is trying to get to their favorite artist, publisher or editor.

They are often so overcrowded that publishers hold raffles for portfolio reviews. You only get a review if you have a winning ticket! They have a lot of actors and movie media, and that's great, but for an aspiring pro, stick to conventions where you can get an editor's attention.

Smaller, regional conventions such as Charlotte HeroesCon, Philadelphia Comic-Con or WonderCon have many attending professionals, but not as much big media attention and far fewer fans in attendance. If you want to get close to your favorite pros, or get a chance to meet top editors, these are great places to go. Philadelphia Comic-Con is an especially good show because it is not crowded and a lot of the pros attend because they can get there easily by train from New York City. So, try out the smaller shows first, but avoid one-day shows. One-day shows usually only have one or two professional guests, and almost no one ever gets a job out of one of those.

ALTERNATIVE PRESS EXPO
www.comic-con.org/ape/
Did you make that minicomic? Here's the place to sell it. If your work is a little off the beaten path, this is the convention for you.

ANIME EXPO
www.anime-expo.org
Huge, very popular anime/manga con. Prepare to be overwhelmed.

ANIMEFEST
www.animefest.org
Good quality regional anime/manga show.

CHARLOTTE HEROESCON
www.heroesonline.com
Probably the easiest to attend and the friendliest of all comics conventions in the U.S. Also, it's less expensive than other major shows with a high pro-to-fan ratio. There's not much emphasis on manga, but many publishers attend.

KATSUCON
www.katsucon.com
A mid-Atlantic, popular anime/manga show. Good location and lodgings, and well organized.

MoCCA ART FESTIVAL
www.moccany.org
The Museum of Comic and Cartoon Art sponsors this annual festival featuring many creators and exhibitors. A great place for art comics, and seeing and being seen.

NEW YORK COMIC CON
www.nycomiccon.com
In only two years, it has become the second-largest comics convention in the U.S. To my mind, it's a better bet than San Diego for making connections with publishers, creators and editors.

OTAKON
www.otakon.com
Another mid-Atlantic convention. It sometimes surpasses Anime Expo in attendance. Expect about 25,000 people. Very good facilities, well organized, fun to attend.

PHILADELPHIA COMIC-CON
www.philadelphiacomic-con.com
Less glitzy and flashy than some other shows, but a very high professional rate of attendance. Get your portfolio reviews here.

SAN DIEGO COMIC-CON INTERNATIONAL
www.comic-con.org
The nation's largest comic and media convention. It's becoming more of a movie and televi-

sion event. Not recommended for beginners. About 150,000 attendees!

SMALL PRESS EXPO
www.spxpo.com
Another convention for the self-publisher, the minicomics auteur and the independent creator.

WONDERCON
www.comic-con.org/wc
Sponsored by the same folks who bring you San Diego Comic-Con, this is a more comics-friendly show and less crowded.

MANGA/COMICS COMMUNITY WEBSITES AND NEWS
Below are just a few of the websites you should keep on your favorites lists.

ANIMEGAMERS
www.animegamersusa.com
A terrific resource for manga, figurines, books and manga art supplies.

ANIME NEWS NETWORK
www.animenewsnetwork.com
Top quality anime news blog.

THE BEAT, Publishers Weekly
http://pwbeat.publishersweekly.com/blog/
One of the most popular and respected industry news blogs, linked with publishing's number-one magazine.

BLUE LINE PRO
www.bluelinepro.com
A comics industry-specific Web resource for art supplies, including supplies for manga artists.

COMIC BOOK RESOURCES
www.comicbookresources.com
Another news blog with a very active fan forum community.

COMIPRESS
www.comipress.com
Manga and anime news. Good, easy-to-read format.

ICv2
www.icv2.com
Good quality industry/business news site with many articles on manga and anime, as well as comics.

MANGA JOUHOU, NEWS AND REVIEWS
www.manganews.net
Exactly what it says. A major fan resource.

MANGA LIFE
www.mangalife.com
Another excellent and popular site for manga news.

THE MANGA RING
http://m.webring.com/hub?sid=&ring=mangaring&id=&list
A huge Weblisting of manga and anime websites.

NEWSARAMA
www.newsarama.com
News and views from a variety of comics industry-related sources: manga, anime, film and television.

NORTH LIGHT BOOK CLUB
www.northlightbookclub.com
Great resource for inexpensive art books with a huge variety of titles and subject matter.

WEBCOMIC WEBSITES
www.comixpedia.org
www.moderntales.com
www.thewebcomiclist.com
www.topwebcomics.com
www.webcomicsnation.com

MAJOR PUBLISHERS

ANTARCTIC PRESS
www.antarctic-press.com
Publisher of many manga, both OEL and imports. One of the oldest manga publishers in the USA.

CPM PRESS
www.centralparkmedia.com/cpmpress
Many manga imports. Not too much original content. Worth a try.

DARK HORSE COMICS
www.darkhorse.com
Publishes wide variety of original work by artists like Frank Miller, but also publishes a good line of manga and manga-inspired work. A publisher that respects creator rights.

DC COMICS
www.dccomics.com
Publisher of comics like *Superman* and *Batman*, but also publishes the CMX manga line, the Vertigo dark fantasy/horror line (*The Sandman*), and the Minx line, focused on comics for girls and young women.

IMAGE COMICS
www.imagecomics.com
Eclectic line of comics ranging from manga to superhero, crime to fantasy. Many creator-owned. Publisher of Todd McFarlane's *Spawn*. Also, my publisher for *A Distant Soil*.

MARVEL COMICS
www.marvelcomics.com
Publisher of *Spider-man* and *Captain America*. Focuses mostly on superheroes, but does have an exclusive Icon line for creator-owned projects by top artists. Some superhero comics are drawn in a manga style.

TOKYOPOP
www.tokyopop.com
Nation's largest publisher of manga, also produces a wide variety of OEL manga.

VIZ MEDIA
www.viz.com
Major manga publisher of imports, also publishes *Shojo Beat* magazine.

BOOKS

Basic Figure Drawing Techniques, edited by Greg Albert, North Light Books
A very simple, clear, and easy-to-understand book for beginners learning academic techniques.

Perspective for Comic Book Artists, by David Chelsea, Watson-Guptill Publications
A more advanced book told in comic form. It contains many tips for getting accurate-looking perspective with less effort. The figure section is not as helpful as the rest, but for the serious student, this volume is a must.

The DC Comics Guide to Coloring and Lettering Comics, by Mark Chiarello and Todd Klein, Watson-Guptill Publications
An invaluable resource with lots of tips for any creator. There's excellent advice about publisher specs. It could use more extensive, updated tutorials.

Writing for Comics With Peter David, by Peter David, IMPACT Books
A look at the art and science of writing comics from an American master. You'll not only learn how to write comics, but also find out a lot about the business. Of use to both manga and Western comics artists.

Girl to Grrrl Manga, by Colleen Doran, IMPACT Books
A style guide for drawing different types of shoujo manga.

Comics and Sequential Art, by Will Eisner, Poorhouse Press
The easiest-to-understand book on comic art as an art form and visual language. Done in an old-fashioned, Western style, but if you ignore the lesson because you don't like the style, you're robbing yourself of an experience with one of the best teachers in the history of the medium.

Graphic Storytelling and Visual Narrative, by Will Eisner, Poorhouse Press
Another invaluable volume about comic art by a master of the form.

Draw Comics With Dick Giordano, by Dick Giordano, IMPACT Books
Teaches mostly Western-style techniques, but it's the work of a pro. You won't know what you did without it.

The Art of the Storyboard: Storyboarding for Film, TV, and Animation, by John Hart, Focal Press
Many comics artists double as storyboard artists. Even if you don't, there is a great deal to be learned about sequential storytelling from this handy and inexpensive book.

Film Directing: Shot by Shot: Visualizing from Concept to Screen, by Steven D. Katz, Michael Weise Productions
An absolute essential for all comics artists. Teaches the must-knows of storytelling technique, set design, lighting and transitions.

Making Comics, by Scott McCloud, Harper
One of the best books ever written for the artist who wishes to create graphic novels and comics. A must-have in every library, for both manga and comics enthusiasts.

Understanding Comics, by Scott McCloud, Harper
The seminal book on comic art visual language and recommended for all manga and comics enthusiasts, advanced students of comic art and all wishing to understand comics.

Perspective Made Easy, by Ernest R. Norling, Dover Publications
An early text on perspective, very clear. A little archaic, but simple to understand, and the drawings are easy to follow. Use this one before trying more complex books.

Color Mixing Recipes for Portraits, by William F. Powell, Walter Foster Pub.
An easy reference for getting the right color combinations for your paintings. Handy and very easy to follow.

Comic Artist's Photo Reference: People and Poses, by Buddy Scalera, IMPACT Books
A solid book of photographs of figures in poses interesting to comic artists. Very handy.

Anatomy: A Complete Guide for Artists, by Joseph Sheppard, Dover
My favorite anatomy lesson book with concentration on muscular and skeletal structure. Alas, not much on drawing the figure in perspective, but some of the clearest tonal pictures of muscles and bones you'll find.

AGENTS

There are only a few agents in the comic book business. It's such a specialized market, few agents know it well enough to be of value to artists. There are legitimate literary agents who work with some graphic novel creators who publish at major book publishing houses like Scholastic. However, these legitimate agents rarely work with beginners. You probably don't need one for starters.

If someone approaches you claiming to be an agent, please proceed with extreme caution. Don't hesitate to go online and ask for advice from creators at major comics industry forums.

Facial Expressions: A Visual Reference for Artists, by Mark Simon, Watson-Guptill Publications
A comprehensive collection of thousands of photos of different people's faces. This is gold for a comics artist. Don't draw without it.

Dreamland Japan, by Frederik Schodt, Stone Bridge Press
The sequel to *Manga! Manga!: The World of Japanese Comics*, this book studies trends in manga, with a focus on mature works, and has an extensive chapter on specific manga artists.

Index